LOOKING AT TEXTILES

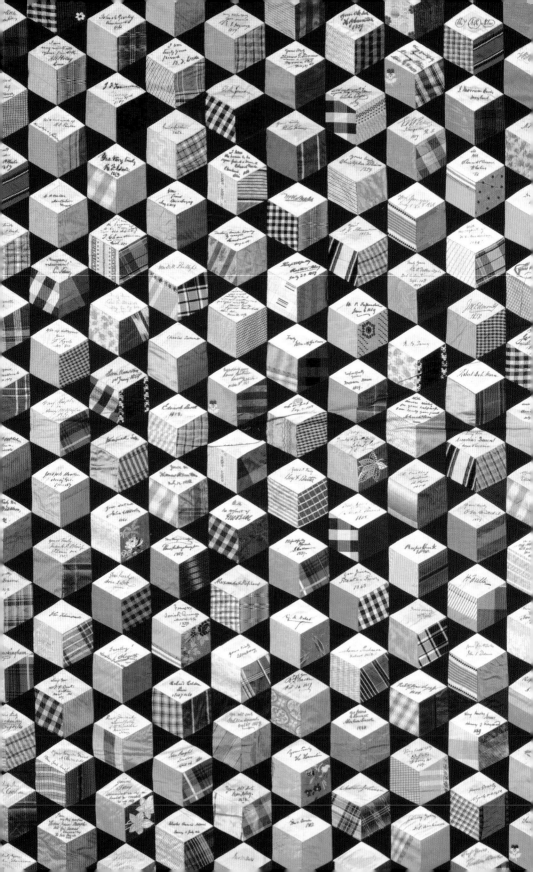

Looking at Textiles

A GUIDE TO TECHNICAL TERMS

Elena Phipps

THE J. PAUL GETTY MUSEUM • LOS ANGELES

Published by the J. Paul Getty Museum

Getty Publications
1200 Getty Center Drive, Suite 500
Los Angeles, California 90049-1682
getty.edu/publications

Ann Lucke, *Editor*
Kurt Hauser, *Designer*
Amita Molloy, *Production Coordinator*

Library of Congress Cataloging-in-Publication Data

Phipps, Elena.
 Looking at textiles : a guide to technical terms / Elena Phipps.
 p. cm.
 Includes bibliographical references and index.
 ISBN 978-1-60606-080-3 (pbk.)
 1. Textile fabrics—Terminology. 2. Textile fabrics—Terminology.
 I. Title.
 TS1309.P49 2011
 646'.11—dc22

 2011011227

Distributed in the United States and Canada by the University
of Chicago Press

Distributed outside the United States and Canada by Yale
University Press, London

Printed in China

Front Cover: Mordant painted and dyed chintz, India, eighteenth century.
Cotton, 10.5 × 18 cm (4 ⅛ × 7 ¹⁄₁₆ in.). Gift of Josephine Howell, 1973-51-67.
© Cooper-Hewitt, National Design Museum, Smithsonian Institution / Art
Resource, NY.
Back Cover: Fragment of a kimono, Japan, late seventeenth century.
Los Angeles County Museum of Art (see p. 62).
Half-title page: *Golf Magic*, designed by Brian Connelly, produced by
Associated American Artists, ca. 1953. Cooper-Hewitt,
National Design Museum, Smithsonian Institution, New York (see p. 71).
Title page: Hexagon autograph quilt, ca. 1856–63. Adeline Harris Sears. The
Metropolitan Museum of Art, New York (see p. 57).
Table of contents: "Yingpan Man," 3rd–4th century. Excavated in Yingpan,
Yuli (Lopnur), China. Xinjiang Institute of Archaeology Collection. Image ©
Corbis. The red and yellow doublecloth coat is magnificently preserved, along
with a miniature garment and embroidered underrobe of this merchant from
western China.

Contents

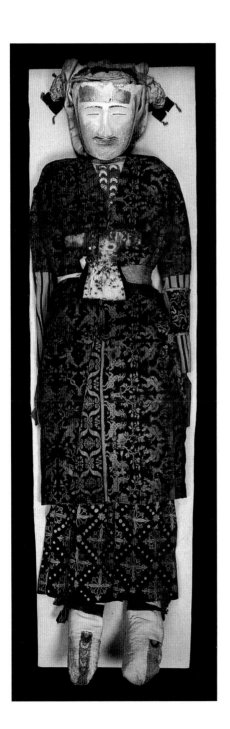

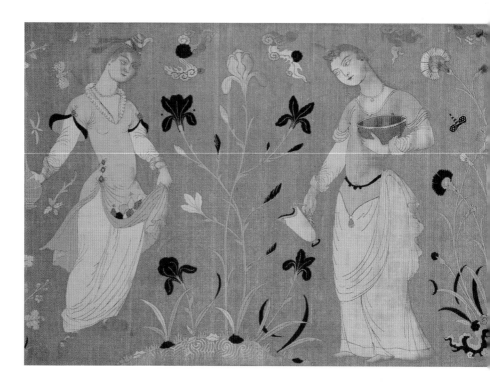

FIGURE 1.
Panel of velvet with figures, Iran, ca. 1610–40. Silk and metal-wrapped silk threads, 217 × 74.5 cm (85⁷⁄₁₆ × 29⁵⁄₁₆ in.). Gift of anonymous donor. CH 1977-119-1. © Cooper-Hewitt, National Design Museum, Smithsonian Institution / Art Resource, NY. Photo: Matt Flynn. Sumptuous polychrome silk velvet with discontinuous warps and a metallic ground.

Introduction

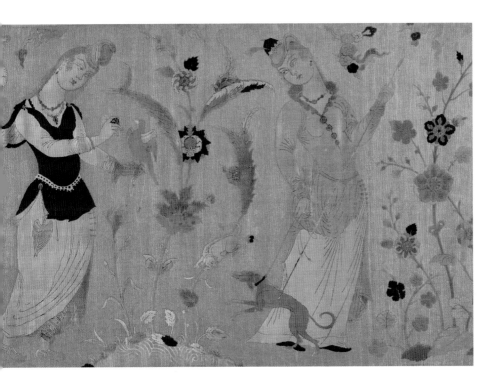

Textiles have been made and used by every culture throughout history. When we look at beautiful textiles in museums that represent the highest artistic achievements of humankind—the great tapestries of medieval Europe with their allegorical narratives, the exquisite velvets of Persia with large scale figures and flower gardens (fig. 1), the complex silks of ancient China, the elaborately embroidered mantles of Peru, and the fine linen shrouds of Egypt—it is easy to forget that textiles are also used as tools. The nets and slings of knotted cords made for fishing and hunting, as well as the garments made for bodily warmth and protection, have aided human survival and contributed to the formation of early civilizations since prehistoric times. Textiles developed as artistic expression in concert with the needs and desires of diverse world cultures, which experimented with the natural resources at hand to establish long-standing traditions for their use. In comparing the ways in which textiles are made from one culture to another, we can see that many use the same basic processes—spinning fiber into yarns, weaving cloth, and embellishing it with designs and colors—but that the details differ. If we look, for example, at plain white cloth, without color or design, from India, China, Peru, and Egypt, each is distinctive and carries with it the hall-

FIGURE 2.
Fragment from a Coptic garment, Egypt, third–fourth century. Wool and linen, 22.68 × 20.95 cm (9 × 8¼ in.). Purchase by subscription. MMA 89.18.252. Image ©The Metropolitan Museum of Art. The plainweave linen is part of a garment that has shellfish purple-dyed tapestry inserts.

marks of its particular time and place (fig. 2). Differences may be detected in the shade and texture of the fiber, the direction and spin of the yarn, the formation of the interlacement, and the treatment of the edges and selvages, among other features. Even in the absence of design, therefore, the materiality of the textile has significance to the culture that created it, as well as to us as observers.

The idea of textiles—their function and meaning—can vary considerably from culture to culture. But in every culture, the way in which a person is clothed—the type of fabric used, its color and patterns—speaks to the identity of the wearer, including his or her age, gender, social position, and role within the community. Most cultures have used special textiles as part of ritual and ceremony, marking stages of life—birth, coming of age, marriage, and death—with particular types of cloth. Textiles have also played a role in diplomacy: luxury textiles were exchanged between cultures to further good will, political gain, economic advantage, courtship, and sometimes all of the above. And of course the production of textiles became a cornerstone of industry and trade from ancient Mesopotamia to the present day.

Textiles are intimately connected with the people who make them, those who both utilize and contribute to long-standing traditions. In some cases, we know that a textile belonged to a specific person: for instance, a rare indigo-blue dyed kerchief, now at the Metropolitan Museum of Art, discovered in the burial caches of the tomb of King Tut-ankhamun (r. ca. 1336–1327 B.C.).[1] However, for the majority of textiles we do not know for whom they were intended, nor the name of their makers, who remain for the most part anonymous. Sometimes artisans worked in groups that can be identified, such as the *accla*, the Peruvian cloistered women of the Inca, who spun and wove for the king

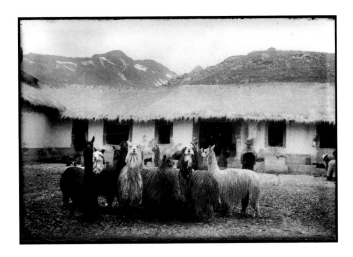

in the late fifteenth century, or the guilded weavers of Lucca or Venice in medieval Italy. But more often they were individual women and men in the household, toiling daily to spin and weave the basic materials of everyday life.

Climate and environment play important roles in determining the materials that were available for use, which influenced these traditions, region to region. In Peru, cotton cultivated in the fertile lowland river valleys became the staple of textile traditions along the coast, while in the high Andean mountains, the silky hair of the llamas, alpacas, and vicuñas was the basis for highland weaving (fig. 3). In China, where native silkworms fed on the leaves of mulberry trees, ancient societies built their textile traditions on the qualities of this long, lustrous fiber and developed innovative weaving techniques to create highly patterned textiles. In Egypt, linen fiber derived from the flax plant was used to produce textiles, especially those for wrapping and accompanying the dead in the afterlife; linen, woven into long lengths of fine, cool fabric, was so highly prized that folded stacks filled the tombs. And in Mesopotamia, Babylonian cuneiform

tablets describe and inventory not only the sheep that were native to the Fertile Crescent—some of the first ovine species to be exploited by humans—but also the textiles produced from their wool and exchanged along caravan routes (fig. 4); as domestication of sheep spread west, it created the basis for economies throughout the greater Mediterranean region. These four fibers—cotton, silk, linen, and wool—constitute the fundamental basis of textile technologies and traditions throughout the world, up to the twentieth century.[2]

With the use of fibers from nature came the desire to add color and design. Early cultures applied earth pigments to textile surfaces and quickly learned how to use plants (and some animals) to create dyes that were more permanent and with a more extensive color palette (figs. 5–7). Roots of the Rubiaceae family of plants, such as the wild species of lady's bedstraw (*Galium verum*), or the cultivated *Rubia tinctorum*, made madder reds, while yellows came from a number of different flowers and various types of tree bark. Blues came from indigo, a colorant found in the leaves of many plants within the genus *Indigofera*. Crimson reds were made from small insects, such as cochineal from the Americas, or kermes and lac from the Mediterranean and Western Asian regions. The use of purple dye from sea mollusks (Muricidae family) in the Graeco-Roman world was restricted to the nobility; similar shellfish native to the rocky shoals of the

FIGURE 5. (right) Dried cochineal insects from Peru used for dyeing brilliant reds and pinks. Author's collection. Photo courtesy of the author.

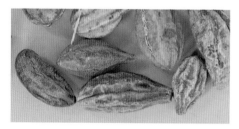

FIGURE 6. (above) Dried myrobalans, the plum-like fruit of the *Terminalia chebula* tree, from India, a source of tannin. Author's collection. Photo courtesy of the author.

FIGURE 7. Dried safflower florettes used in Asia to dye bright pink. The dye produces a brilliant color but is very sensitive to light. Author's collection. Photo courtesy of the author.

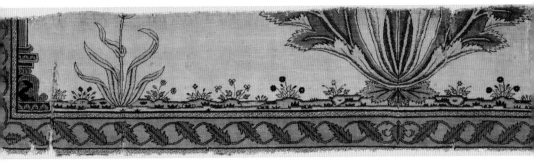

Figure 8.

Fragment of a carpet with niche and flower design, Kashmir or Lahore, Mughal period (1526–1858). Silk (warp and weft) and pashima wool (pile), asymmetrically knotted pile, 15.2 × 64.8 cm (6 × 25½ in.). Bequest of Benjamin Altman, 1913. MMA 14.40.722. Image © The Metropolitan Museum of Art. This exquisite carpet fragment has 2,193 knots per square inch.

Pacific Ocean were used by the Maya in Mexico and the Nasca people farther south in Peru. The discovery of dye plants and animals and the other important aids to create the dyes, such as mordants or mineral salts, contributed not only to the creative production of textiles but also to the development of science, as their processing and use required intimate knowledge of aspects of botany, agriculture, and chemistry, among other fields, fostering experimentation and discovery.[3]

Trade in textiles was a signature element of early civilizations. Being lightweight and portable, textiles—as whole objects, and in their component forms, such as yarns and dyestuffs—helped to spur the early establishment of long-distance trade routes, such as the Silk Road between China and the West; the Iberian galleon trade between the New World and the Old (and to Asia) in the sixteenth to eighteenth centuries; and the Indian maritime trade, via the Dutch and British East India companies. All of these routes opened new markets in the global trade in textiles and textile products and brought about an exchange of ideas, technologies, and aesthetics that created new approaches to the production and use of textiles.[4]

Artisanry and craftsmanship in making textiles excelled in many cultures, with highly skilled artists employing the finest of materials. Sometimes the resulting products were luxurious fabrics, such as the crimson-and-gold Italian velvets that Venetian ambassadors sent to the Ottoman emperor Mehmed II (r. 1444–46, 1451–81), or furnishing fabrics, such as the elaborately embroidered late-seventeenth- to early-eighteenth-century French silk bed-hangings for the *lit à la duchesse* in the style used in the bedchambers of Versailles.[5] The courts of Europe were adorned with large tapestries of wool, silk, and gold made from designs created by the great artists of the period and woven in exquisite detail by master weavers in the Netherlands, France, Italy, and Spain. Knotted pile carpets produced by Safavid Persian and Mughal Indian weavers, especially those of the sixteenth and seventeenth centuries, had hundreds or even thousands of knots per square inch, delineating wildly eccentric flower gardens and dazzling geometry (fig. 8). This knotted art form has been in existence for thousands of years, as we know from the famous fifth-century B.C. Pazyryk Carpet now at the Hermitage Museum in St. Petersburg, considered to be the earliest knotted pile carpet preserved.

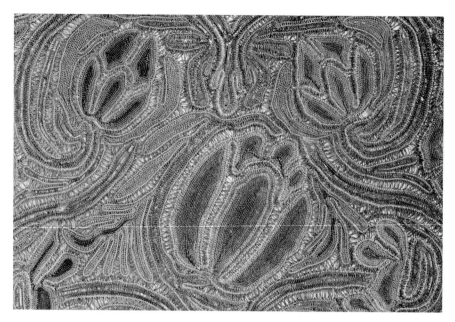

FIGURE 9.
Detail of embroidered openwork cover, Spain or Italy, ca. 1650. Silk and metallic thread lace, 134.6 × 176.5 cm (53 × 69½ in.). Costume Council Fund. LACMA M.87.112.6. Digital Image © 2009 Museum Associates / LACMA / Art Resource, NY.

Not all textiles represent the art of luxury, but rather embody the beauty and simplicity of the everyday arts. The indigo blue–dyed working cloths of medieval European craftsmen, the Amish quilts made of polychrome woolen scraps, and the stripes and plaids used in household linens all over the world have great appeal in their utility and modesty. Textiles, in all their forms, can be appreciated on multiple levels, for their beauty and tactile physicality, their sophistication in aesthetic and design, their craftsmanship and artistry, and their visual and intellectual impact (fig. 9).

Looking Closely at Textiles

When we look at textiles, we can see, feel, and touch (except for museum objects!) all of these aspects and they spark our imaginations. Often questions arise: what is this made of, and how was it made? Sometimes tools and evidence of the working process have been preserved that provide us with clues: the thousands of doughnut-shaped loom weights from the first millennium B.C. excavated at Gordion in Anatolia; the caches of bronze needles in Egyptian tombs; the weavers' personal workbaskets buried in the deserts of Peru.[6]

Sometimes the only clues we have to ancient loom technologies come from depictions on pottery or in wall paintings, which record their use and form. In more recent times, illustrations from books and manuscripts have helped us to understand the technical components of looms and other textile machinery from past ages. Among these we may include the *Encyclopédie* of Denis Diderot (first published 1751–72) with illustrations of French silkweaving technologies of the period (see p. 67) and the volumes

entitled *Tian gong kai wu (The Works of Heaven and the Inception of Things)* on Chinese technology compiled by Song Yingxing (b. 1587) in 1637, with hand-colored woodblock prints showing all aspects of sericulture and silkweaving, including the stages of caring for the silkworm and the preparation of silk yarns for weaving on the loom (fig. 10).[7]

Weavers and dyers created and used their own workbooks and sample books. Some of these provide valuable details on various weaving and dyeing processes, including weights and volumes of dyebath components, which enable us to reproduce methods following ancient and historic practice. One such is the *Plictho de l'arte de tentori (The Plictho: Instructions in the Art*

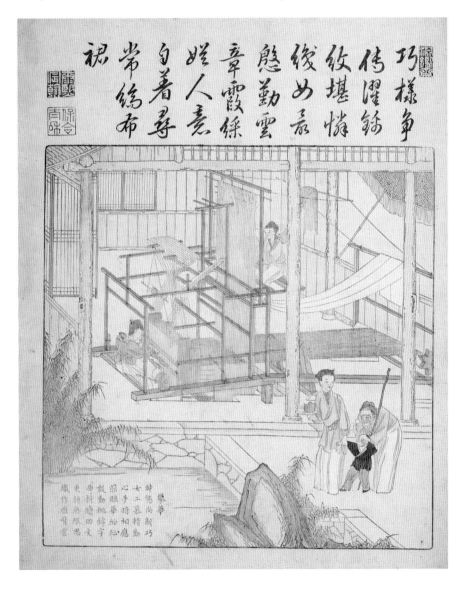

of the Dyers) by Giovanventura Rosetti (fl. 1530–48), the first published book of dye recipes, printed in Italy in 1548. Some dyers preserved not only written formulas but also careful records of their experimentation with dyes and recipes. We have, for example, the Merton Abbey dyers in England, who later produced the fabrics designed by William Morris (1834–1896), methodically conducting tests for washing and lightfastness, with swatches preserved from their experiments (fig. 11); Morris himself kept track of the results of his tests in his journal.

Sometimes, however, we have only the textiles themselves—with no history, no signature, no clue as to their origin or provenance. It is here that we take up the challenge to bring together a range of experience to place these objects in a context, or to group them with others that share physical, technical, or aesthetic features. With careful examination, many orphaned pieces, whether whole objects or fragments, can be reunited with related textiles and placed within a logical chronology of textile history.

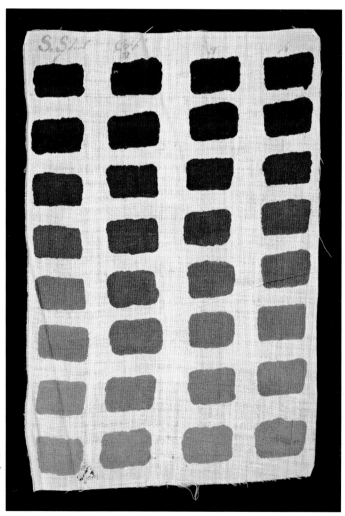

FIGURE 11.
Mordant tests with copperas and lye, Merton Abbey Printworks, Surrey (U.K.), dated Jan. 9, 1800, on attached note.
GRI 850408.

In this exploration, the *condition* of a textile tells us a great deal about the history of the object—its original form and function and the history and pattern of use. Has it been carefully preserved, like a relic in a wooden box, or has it been worn through repeated use, mended through time, and reused in another form? Sometimes, even though incomplete, fragments can be rejoined with others from its original cloth. And even in a fragmentary state, a portion of a textile can still be a magnificent work of art: powerful in its aesthetic and superb in its craftsmanship (fig. 12).

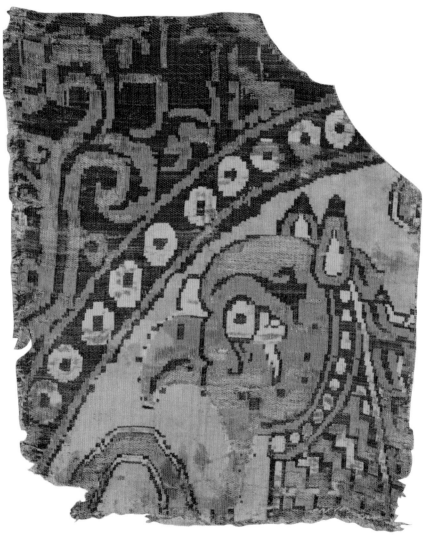

Figure 12.

Woven silk fragment with part of a scene of a griffin attacking an elephant, Byzantine, 999–1100. Silk.
V&A 764-1893. © Victoria and Albert Museum, London. The compound twill structure (*samit*) can be
seen here in the worn areas of the griffin's face, where the yellow silk weft has worn away, revealing white
and blue wefts that are bound at the back and not normally visible from the front.

FIGURE 13.

Front of textile fragment with pattern of hares (detail), Chinese, thirteenth–mid-fourteenth century. Silk and metallic thread, 50 × 49 cm (19¹¹⁄₁₆ × 19⁵⁄₁₆ in.). Gift of Patricia and Henry Tang, 1998. MMA 1998.438. Image © The Metropolitan Museum of Art. Photo: author.

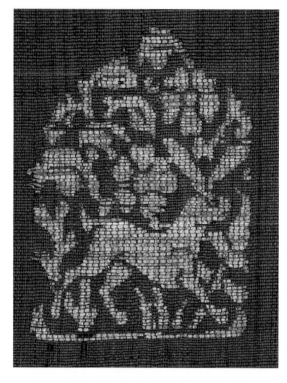

FIGURE 14.

Back of textile pictured in fig. 14. Note the discontinuous use of gold wefts (composed of gold leaf on a paper substrate) used to form the pattern. Also, compare the color differences between front and back: the back retains the more original hue, and the front has yellowed from exposure to air and light. Image © The Metropolitan Museum of Art. Photo: author.

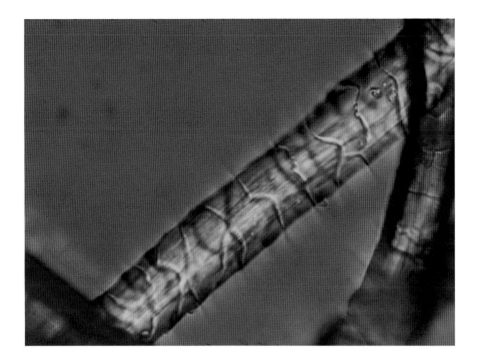

FIGURE 15.
Wool fiber, x400
magnification.
Photo: author.

The condition of the textile can also help our study of the *structure* of the cloth: worn surfaces often reveal exposed areas and features underneath that normally would have remained hidden. So, too, the *colors* provide clues to where it was made and how it has been kept. Knowledge of flora and fauna used for dyes sometimes allows us to locate the source of the dye and possibly the object in a particular place. Certain colors can be preserved for centuries or even millennia, while others begin to fade after a few hours' exposure to sunlight. Examining the back of a textile sometimes gives us a clearer sense of the original color—and allows us to imagine the impact of the textile when it was new. From the back, we can also see details of weave structure and embroidery stitching. We note whether the threads float along the back or were interlaced in their own structure, and whether design elements, such as the costly gold thread used to create the hares in this Mongol Chinese brocade, follow along the entire width of the cloth or are used only in the specific areas called for by the design (figs. 13–14).

The microscope is often helpful for identifying materials as well as structures. At x5 to x20 magnification, we can usually see weave structures. Increasing the magnification to x100 or x400 allows us to see individual fibers: the scales on a wool fiber or the twist of a cotton one become readily visible (fig. 15). Scientific examination using X-rays, Raman lasers, and various chemical separation procedures can help identify the components of the colors and dyes as well as metals.[8] In some cases, however, experience is our best guide: we use our eyes or our hands to explore the surface, sensing the difference between the smooth touch of silk and the coarse warmth of wool, the fine, cool feel of linen or the remarkable lightness of guanaco (fig. 16).

FIGURES 16, 17.
Details from tapestry, *The Creation of Eve*, southern Andes, early seventeenth century. Tapestry weave, cotton warp and camelid weft, 264 × 251 cm (104 × 94⅞ in.). Circulo de Armas, Buenos Aires. Photo: author. Colonial Andean weavers utilized many creative approaches to rendering images in tapestry, such as bicolored yarns and eccentric wefts to accentuate the face of the vizcacha (a chinchilla-like mammal), which nibbles on Adam's leg.

As a conservator for over thirty years and one interested in the details of the materials and techniques used in textiles throughout history, I approach their examination from a physical perspective. When first looking at a textile, I try to understand what it is, and to see how it was made and what it was made of. What are the fibers? What is the weave structure? What is the warp direction (as opposed to the weft)—in other words, what was the direction for weaving? Was the design executed by hand or was it programmed into a mechanical device on a loom? What are the colorants, and where are they from? Is the textile complete or is it a fragment of a larger piece; if so, of what and how was it used or reused? Are there others like it? How does it fit into the history of textile traditions?

This book is a guide to help answer some of these questions, through a presentation of the vocabulary and ideas used in examining and describing textiles. Our aim here is not to present the whole story of textiles but to elucidate some basic and important terms that we hope will increase understanding of the materials and techniques used to create them. All this begins with looking at textiles, and looking as closely as possible. Understanding a textile's structure, fiber, and dyes, we can progress to a broader appreciation of its meaning and cultural context. The more we can train our eyes, the more we can appreciate the complexity, beauty, and significance of the art of textiles.

NOTES

1. Three kerchiefs or headcloths were found in the burial cache of King Tutankhamun (MMA 09.184.217, 218, and 219). One, 09.184.217, is indigo-dyed.

2. For more about the origins of early textile civilizations, see Forbes (1964) and Weibel (1952).

3. For more about dyes, see Brunello (1973) and Cardon (2007).

4. On trade, see Irwin and Brett (1970) and Watt and Wardwell (1997).

5. See Bremer-David (1997).

6. For more on Gordion loom weights, see University of Pennsylvania excavations at http://sites.museum. upenn.edu/gordion/. Egyptian bronze needles belong to The Metropolitan Museum of Art (MMA 22.1.985). Peruvian weavers' workbaskets can be seen in a number of museum collections.

7. *The Plictho* can be found in facsimile: The *Plictho of Gioanventura Rosetti*, trans. Sidney M. Edelstein and Hector C. Borghetty (Cambridge, Mass., 1969). Song (1966) is a translation of the Chinese work.

8. See Marco Leona, "Materiality of Art," *MMA Bulletin* 67, no. 1 (2009), 4–11.

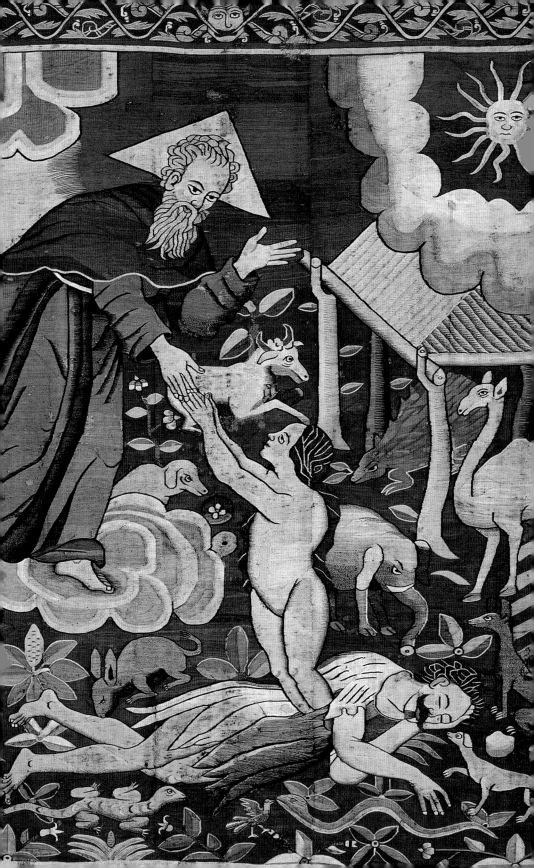

Glossary

ABRASH

Meaning "mottled" (from the Persian), the term refers to uneven coloration within monochrome areas, for example, on a solid-color central field of a Persian or Turkish carpet. *Abrash* may sometimes be an accidental effect of a weaver's process—using yarns of the same color dyed in different dyebaths—but it was often used deliberately as an aesthetic choice: it creates a lively and variegated plane of color, adding depth and visual interest.

ALUM See MORDANT.

APPLIQUÉ

An additive process of attaching design components in layers onto the surface of an object, such as quilts or garments. The flowers on a Baltimore Album quilt, for example, were first composed of various fabrics, forming the petals of the rose, stitched one to the other. Then the entire design unit is attached to the quilt surface using small stitches around its perimeter.

BASIC WEAVE STRUCTURE See WEAVE STRUCTURE.

APPLIQUÉ
Appliqué rose from a
presentation quilt (detail),
Baltimore, Md., ca. 1849.
Design attributed to
Mary Hergenroder Simon
(American, 1808–1877).
Cotton and silk velvet,
269.9 × 263.5 cm (106¼ ×
103¾ in.). MMA 1974.24.
Image © The Metro-
politan Museum of Art.
Photo: author.

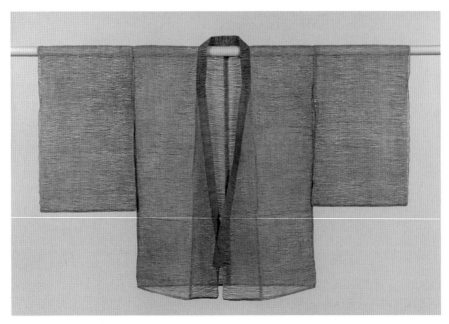

Bast fiber

Long FIBERS coming from the outer part (phloem) of the stems of certain plants. *Bast fibers* have long been cultivated, particularly in Europe and Asia, and are among the earliest fibers used in textile production. They come from both wild and cultivated species, such as FLAX (*Linum usitatissimum*), *stinging nettles* (*Urtica dioica*), *ramie* (*Boehmeria* sp.), HEMP (*Cannabis sativa*), and *jute* (*Corchorus* sp.). Because it can be difficult to differentiate among the various fibers of this group without the aid of a microscope, the term "bast fiber" is used to describe them. See also LINEN.

Block printing See PRINTING.

Braiding See PLAITING.

Brocade

Commonly used to describe many types of patterned fabrics, technically speaking the term denotes a specific type of textile weave. A *brocade* is a fabric in which woven design is created with SUPPLEMENTARY pattern WEFTS that are DISCONTINUOUS—that is, the pattern wefts do not pass across the whole width of the woven cloth, but are used only where a particular color is called for in the design. To brocade is to create pattern in this way.

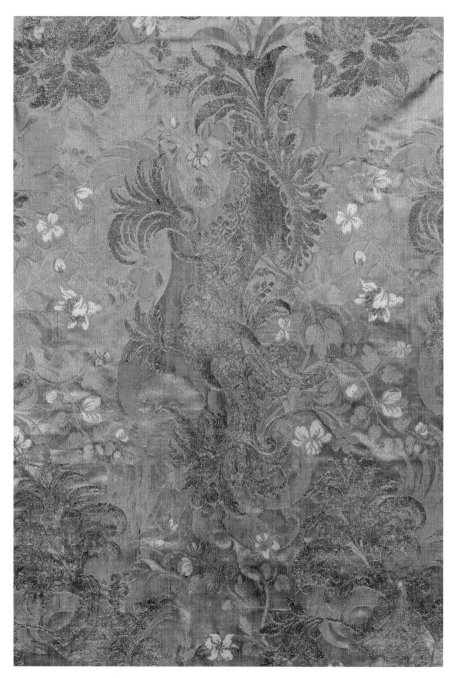

BROCADE

Brocaded Bizarre silk damask (detail from side panel) from a set of bed hangings, French, ca. 1690–1715.
Silk, with silver metallic wrapped thread. Overall dimension 415.9 × 181.6 × 182.9 cm (13 ft. 7¾ in. ×
5 ft. 11½ in. × 6 ft.). JPGM 79.DD.3. The blue damask ground fabric is brocaded with pink, yellow, and
white silk, used only where needed for the design, while the silver threads travel selvage to selvage,
bound to the back when not visible on the front.

CAMELID HAIR

Camelids—such as the *llamas* (*Lama glama*), *alpacas* (*Vicugna pacos*), and *vicuñas* (*Vicugna vicugna*) of South America, or the *Bactrian camel* (*Camelus bactrianus*) of Central Asia—have body hair and/or an undercoat (in the case of the Bactrian camel) that has been valued as textile fibers for millennia. (The *dromedary camel* of the Middle East and Egypt [*Camelus dromedarius*] is not generally used for its fiber.) Early domestication of camelids in the Andes favored breeding animals for the color, quality, and length of their hair. The vicuña, whose extremely fine hair is especially prized, has not been domesticated. The Bactrian camel has shorter, stiffer hair than its South American cousin, but its undercoat hairs can be comparable in softness to mohair.

CARTOON

A drawing or painting (generally made to full scale) used as a template or guide for weavers to execute the design of a TAPESTRY.

CHINTZ

A dye-patterned COTTON cloth with a glazed surface, originally from India. The term, variously spelled as *chint*, *chints*, or *chites*, derives from the Hindu word *chitta*, meaning "spotted cloth" or "colorful cloth" (Gittinger, 1982; Irwin and Brett, 1970). The deceptively simple term "colorful cloth" referred, in fact, to the results of a highly complex process using a variety of methods for creating bold, colorful designs. These methods include selective and sequential application of MORDANTS, RESIST DYEING, block PRINTING, and/or hand drawing and painting, along with dyebath immersion and bleaching, requiring considerable preparation and skill, and a number of different tools. The colors, usually variable shades of red, blue, purple, green, yellow, and black, were produced with a limited number of dyestuffs. These, include INDIGO blue, plant reds—from the native Indian MADDER roots *munjeet* (*Rubia cordifolia*) and *chay* (*Oldenlandia umbellata*)—and several yellow dye sources. These few basic dyes were creatively multiplied into many colors on the cotton surface through the use of the mordants alum and iron, along with *myrobalans* (a dried fruit whose TANNIN also acts as a mordant) (see Introduction, fig. 6). Applying the alum and iron mordants in different areas of the design, then immersing the cloth in a single dyebath, yields multiple colors. For example, using a madder dyebath, alum produces red while the iron produces purple. Overdyeing of colors (for example, hand-applying a yellow over an indigo-blue dyed area to make a green) created further color possibilities. After dyeing, the cloth was beaten to obtain the characteristic shiny, smooth, glazed surface.

The Indian master dyers produced sumptuous chintz for domestic use, such as tent panels, floor and table covers and the ritual *kalamkāri* cloths covered with religious imagery. Dyers on the Coromandel coast of southeast India produced especially fine examples, which became the basis for export trade in the sixteenth through eighteenth centuries, first with the Portuguese and then with the English and Dutch. Indian chintz achieved popularity in the Indonesian, Malaysian, and

CHINTZ

Palampore (bedcover), Indian (Coromandel coast, northern region), early eighteenth century. Cotton,
mordant painted and dyed, resist dyed. 271.8 × 197.5 cm (107 × 77¾ in.). Bequest of George Blumenthal
and Gift of Indjoudjian Frères, by exchange and The Friends of Islamic Department Fund, 1982.
MMA 1982.66. Image © Metropolitan Museum of Art.

other regions of Asia and became the currency of trade: the British and Dutch East
India companies exchanged these fabrics for treasured spices. Europe also developed
a taste for the colorful cotton cloth, especially the *palampores*, large cotton bedcov-
ers with the "tree of life" design. Eventually, France, Holland, and England began
producing their own version of the cloth, which required the development of new
industrial printing methods.

COCHINEAL

Textile fragment (detail),
Peru (Recuay culture),
fourth–sixth century.
Camelid hair, tapestry
weave, 33 × 82.6 cm
(13 × 32½ in.). Gift of
Carnegie Corporation
of New York, 1930.
MMA 30.16.7. Image
© The Metropolitan
Museum of Art.

COCHINEAL

A brilliant red DYE produced by the female of the insect species *Dactylopius coccus* that lives on the *Opuntia* cactus, native to Mexico and South America. It was highly valued in pre-Columbian times and used as both a textile dye and a painting pigment by ancient Mexican and Andean cultures. Its use has been confirmed in textiles dating to approximately the third to first century B.C., preserved in desert burials on the Paracas Peninsula of southern Peru (Saltzman, 1986). In the sixteenth century, shortly after their arrival in the Americas, the Spanish established trade in *cochineal*, considered one of the treasures of the New World. It was brought to Europe by the ton on the annual *flotas* or fleets of Spanish trading vessels and was incorporated into the thriving textile industries of Spain and Italy, as well as France and the Netherlands. Cochineal was introduced into Asia via maritime trade between the Americas and the Philippines, and into the Middle East by both land and sea routes. By the nineteenth century, it was the world's leading source for red color in textiles. The primary coloring component of cochineal is carminic acid, which produces a deep pinkish-red hue that can be adjusted in the dyeing process to create a range of colors from blue to purple to orange. Today, it is used in the cosmetics and food industries as a colorant for many products, from lipstick to Campari.

COMPLEMENTARY

In weaving, this term describes the relationship between two or more elements—WARPS or WEFTS—often differentiated by color, that perform the same function in the WEAVE STRUCTURE, forming a design. *Complementary* yarns often work in pairs of two or more different colors, so that when one is used on the front surface to compose the design, the other may float or interlace at the back. Complementary weaves can be WARP-FACED or WEFT-FACED. Andean weavers are noted for using complementary warps to create narrow bands of designs in mantles and belts, while Byzantine weavers used complementary wefts to create polychrome compound SAMITS and other weaves (see WEAVE STRUCTURE).

COMPOUND WEAVE

A *compound weave* is a general term for a fabric structure that is more complicated than a basic weave (see WEAVE STRUCTURE), meaning that it is composed of multiple sets of WARPS and/or WEFTS, each with different functions. Creative innovations in constructing compound weaves enables the production of sophisticated design features, such as the juxtaposition of textures within the fabric to highlight the design elements within a foreground and background, or the introduction of multiple colors. Some compound weaves combine two structures; examples of this type include DOUBLECLOTH and LAMPAS. Another group of compound weaves uses a single binding structure—PLAIN WEAVE or TWILL to create a single continuous

Woven silk (lozenges with rosettes, white on purple), Byzantine, ca. 1200–1399. Silk, detail. V&A 8249-1863.
© Victoria and Albert Museum, London. The purple and white surfaces of the compound twill is created
with the aid of the brown "inner" warps (now exposed) that separate the two colors.

fabric surface—but in order to incorporate polychrome designs, it uses sets of COM-
PLEMENTARY elements in one direction (warps or wefts) that are bound by one set
and separated by a second or "inner set" of elements (warps or wefts) in the other
direction. One example of this type in a WEFT-FACED plain weave is called *taqueté*
(from the French) or compound plain weave with inner warps (see the illustration
at DESIGN REPEAT); in a weft-faced twill, it is called SAMIT. These structures are also
found in WARP-FACED versions.

Historically, weaves that combine multiple sets of warps and wefts require inno-
vations to the basic LOOM. The use of compound weaves is associated with the
development of complex woven pictorial designs—FIGURED designs—which form
repeats across the length and width of the fabric. The combination of structures
allows for patterning to be clearly defined, either by the juxtaposition of the warp
and weft faces of the multiple structures (as in a lampas), or by enabling the weaver
to create the structure using different colors in a regular fashion, bound by the weave
structure (as in a samit). Examples of early compound weaves have been found from
ancient China, Sāsānian Mesopotamia, Roman Egypt, medieval Europe, and pre-
Columbian Peru.

COPPERPLATE PRINT

Design printed on the surface of COTTON or LINEN fabric using etched copper-
plates. *Copperplate printing*, which began in the seventeenth century, allows elabo-
rate graphic designs to be transferred onto cloth. Once the plates are etched, DYE

(generally with a thickening agent) is applied onto the plate's surface and the excess is wiped off; the colorant remains solely in the etched grooves. The plate is then pressed onto the fabric surface, transferring the colored design. Fine line drawing, often in monochrome, is characteristic of copperplate prints, which became known as TOILES DE JOUY, after the textile printing factory established by Christophe-Philippe Oberkampf (1738–1815) in the town of Jouy-en-Josas, near Versailles, France.

COTTON

Cotton fiber comes from the seed hair of plants of the genus *Gossypium*. The various cultivated species of cotton, including *G. barbadense*, *G. arboreum*, *G. hirsutum*, and *G. herbaceum*, originated in the Americas, India, and Africa. Being a short FIBER, cotton is generally spun into fine YARNS. Viewed under magnification, the cotton fiber has a natural twist to it, which distinguishes it from other fibers. The fiber,

composed primarily of cellulose, is generally white, although naturally pigmented cottons, include shades of brown, cream, gray, pink, and green, occur in species from the Americas. The antiquity of cotton is attested to by the pre-ceramic finds from fishing cultures in Peru (ca. 2000–1800 B.C.) and the Indus Valley, where textiles from Mohenjo-Daro in present-day Pakistan date to as early as 3000 B.C.

COUNT

The number of the various weaving elements of a textile per unit of measure, for example, the WARP count, the WEFT count, or the knot count. While the YARN count of a textile can be an indicator of quality or fineness of weave—a high warp and weft count indicates a higher density of weave—it is not the only factor in assessing the quality of a textile. The warp count of a European TAPESTRY, for example, may be only 6–8 per centimeter with a weft count of 30, while an Inca tapestry garment may have 20 warps with 100 wefts per centimeter, but both textiles were highly valued in their respective cultures.

To document a WEAVE STRUCTURE, the *count* is taken according to each yarn's function within the weave, so it is important to understand how the textile has been woven. For example, the warp count of a LAMPAS weave, which has two sets of warps, a ground warp and a pattern warp, will have a count for each, taken separately. Wefts, again, are counted by their function, so that if a structure uses three colors together in one pass of the weft, they are only counted as one: if each color represents a different structural function (such as ground weft, pattern weft, or supplementary weft), then they are counted separately. For rug knots, the count is taken following a single weft row, and sometimes, a count per square inch or centimeter is used, multiplying counts across warp and weft. In the textile industry, standardized warp counts reflect the spacing of the threads on the loom.

DAMASK

Fragment of a damask with heraldic design, Italy, ca. 1500–1550. Silk, 66 × 58.4 cm (26 × 23 in.). Fletcher Fund, 1946. MMA 46.156.116. Image © The Metropolitan Museum of Art.

DAMASK

A weave that is constructed of opposing faces (the WARP face and the WEFT face) of one single WEAVE STRUCTURE (generally TWILL or SATIN). Often woven in monochrome, the design is visible through the juxtaposition of the two faces of the weave structure presented on the same surface of the textile. Usually, the WARP-FACED surface (vertically oriented) forms the ground and the WEFT-FACED surface (horizontally oriented) forms the pattern. The play of light brings out the different surface textures and makes visible the design, which may be very subtle. *Damasks* can be woven in SILK, COTTON, WOOL, or LINEN, with a number of different types of patterning from geometric to floral to narrative scenes.

Denim

Traditionally, an INDIGO-dyed COTTON TWILL cloth. A WOOL twill cloth dyed with woad, the European indigo-bearing DYE plant, was produced especially in the southern French textile manufacturing center of Nîmes from the medieval period. The cloth, exported throughout Europe, particularly in the seventeenth and eighteenth centuries, was referred to as *serge de Nîmes* (twill from Nîmes). This is considered to be the origin of the term *denim*. See illustrations under Indigo.

Design repeat

A *design repeat* is the minimum dimension (height and width) required to create a mechanically repeated design or pattern, in either printed or woven fabrics. Determining the design repeat of a fabric can be a challenge, as many cultures use mechanical repeats in the weaving and printing process, but incorporate creative design elements that mask the repetition. Also, some designs may obviously repeat—for example, a deer motif used repeatedly across the width of a fabric—but the boundaries of the technical repeat unit may not be congruent with the motif itself. The repeat may instead be defined from center to center of a design, beginning in the middle of one motif and ending in the middle of the next.

Design repeats can follow a straight repeat system, a point repeat system, or a combination of the two. The *straight repeat* utilizes the design unit—for example, a bird facing right—repeating horizontally across and/or vertically up and down the fabric. If the same motif alternately faces right and left in each row, this represents a *point repeat* system: in other words, the point repeat "flops" (mirrors) the design across a vertical or horizontal axis. Sometimes the point repeat is what creates a whole motif, as in the Mongol textile motif of confronting lions within a roundel. Depending on the organization of the visual pattern, particularly the symmetry of its composition, some design repeat units constitute only one-quarter of the entire pattern. This quarter unit can then be "flopped" along a horizontal axis, then flopped again along the vertical axis, forming the entire pattern.

DESIGN REPEAT
Textile fragment, Egypt, Coptic period (third–twelfth century). Wool, 39.4 × 13.3 cm (15½ × 5¼ in.). Rogers Fund, 1946. MMA 46.70. Image © The Metropolitan Museum of Art. The design unit of this compound weave (*taqueté*) textile with the inscribed bird forms a straight repeat horizontally and vertically.

In WEAVING, the design repeat constitutes the minimum number of WARPS and WEFTS used to create a particular pattern; by utilizing repeat systems, the weaver is able to reduce the number of steps used to produce complex patterns, particularly in large-scale designs. This is particularly true as the structure of the design repeat impacts how the design is set up on the LOOM (Sonday, 1987). The identification of the different types of design repeat systems used by different cultures can indicate how complex weaving was executed as loom technology developed.

DESIGN REPEAT
Blue and gold cloth with figural motifs, made into a dalmatic in Europe, Iran, fourteenth century. Silk and gold thread, h. 171.9 cm (68¾ in.). V&A 8361-1863. © Victoria and Albert Museum, London. While the alternating rows of deer and pelicans face in opposite directions, as in a point repeat, the two together actually form the single woven design unit and follow a straight repeat.

DESIGN REPEAT
Cloth of gold (detail): winged lions and griffins, Central Asia, mid-thirteenth century (ca. 1240–60). Lampas, silk and gold thread, overall 124 × 48.80 cm (48¹³⁄₁₆ × 19³⁄₁₆ in.). Purchase from the J. H. Wade Fund. Cleveland Museum of Art 1989.50. Image © The Cleveland Museum of Art. The motif of confronting lions in a medallion is constructed as a horizontal point repeat design unit of one half the image, flopped to compose the single medallion. This unit is then used as a straight repeat vertically.

DISCONTINUOUS

Discontinuous elements—either WARPS or WEFTS—do not span the entire width or length of a cloth; rather they are present only where needed. TAPESTRIES, for example, use discontinuous wefts to create color areas for the design. Discontinuous wefts are often SUPPLEMENTARY, as, for example, those used in a BROCADE. Weaving with discontinuous warps, though rare, was used extensively in the Andes and in some highly refined Persian velvets (see Introduction, fig. 1). WEAVING with discontinuous warps requires special aids to maintain warp tension at the points of color change. Some textiles may have both discontinuous warps and discontinuous wefts. (See the illustration at COTTON.)

DISTAFF

A stick used to hold FIBERS (usually WOOL or LINEN) that have been cleaned and prepared for SPINNING.

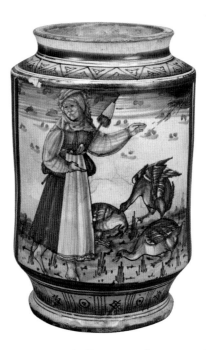

DISTAFF
Majolica jar with a woman holding a distaff, Italian, ca. 1500–25. Tin-glazed earthenware, h. 24.76 cm (9¾ in.), w. (max) 16.83 cm (6⅝ in.). JPGM 84.DE.112.2. The female figure's distaff appears to be tucked into her belt and held under her arm.

DOUBLECLOTH

A WEAVE STRUCTURE composed of two sets of WARPS and two sets of WEFTS: each interlaces with its respective set. The result is a fabric that generally has a minimum of two color areas, for example, blue and red, as in the American coverlet pictured here, where the blue warp is interlaced with the blue weft, and the red warp with the red weft. These color areas are woven in two layers that intersect as the design requires, sometimes forming a pocket in between. *Doublecloth* is generally reversible back to front and is found throughout the world, from China to the Andes, in many variations. (See also Contents page, with illustration of Chinese Yingpan man's cloak.)

DRAFT

A weaver's technical plan to document the LOOM setup for repeatable pattern weaving. The *draft*, a series of technical drawings, indicates how a specific fabric weave and/or pattern is set up on the loom, including the organization of the WARPS within the HEDDLES and shafts, and the order of the lifting mechanisms—the foot treadles—which govern how the WEFTS will be inserted.

DRAFT

Page from a weaver's thesis book, England, seventeenth–eighteenth century. Leather, paper, ink, 31 × 20.5 × 1.4 cm (12³⁄₁₆ × 8¹⁄₁₆ × ⁹⁄₁₆ in.). Museum purchase through gift of Mrs. Clarence Webster. CH 1958-30-1. © Cooper-Hewitt National Design Museum, Smithsonian Institution / Art Resource, NY.

DRAWLOOM

The *drawloom* is a special type of LOOM designed to facilitate the WEAVING of FIG-URED polychrome fabrics with intricate design details that repeat across the width and length of the cloth (see Introduction, fig. 10). Composed of multiple parts, including the basic loom components of front and back beams, shafts, and peddles operated by the weaver, the drawloom also has an upper section (a figure harness) to control the design. The upper section is fitted with a set of *drawcords* that can be pulled by an assistant (called the *drawboy*), often positioned at the top of the loom or to the side, to create the designs. Methodically prepared, the drawloom facilitates the lifting of individual cords attached to shafts, which lift or lower individual warp threads according to the design.

Scholars still debate whether the drawloom originated in China or the Middle East. Some of the earliest drawloom-woven fabrics have been found in Egypt but are thought to be of Syrian origin. The drawloom was superseded by the JACQUARD LOOM mechanism, developed in the eighteenth century, which achieved a similar result using a series of punched cards for warp selection, eliminating the need for the drawboy.

DYE

A soluble colorant that penetrates a FIBER or material, forming a physical and/or chemical bond with or without the aid of auxiliary agents. A *dye* differs from a *pigment*, an insoluble colorant that generally requires an adhesive or binding medium in order to attach or bond to the surface of a fiber or textile. (Certain pigments are made by rendering organic dyes insoluble; these are referred to as *lakes*.) Dyes are generally categorized as either *natural* or *synthetic*.

NATURAL DYES are made from organic materials that come from plants and animals. Dyes of plant origin may be made from the roots, stems, bark, leaves, or flowers. Dyes of animal origin are obtained from the secretions and bodies particularly of certain insects and mollusks. Dyes can be further classified by their behavior in the dyeing process. *Direct dyes* can be placed in water and dyed directly to a fiber. *Mordant dyes* require an additional substance to help bind the fiber to the dye (a metallic salt or MORDANT, such as alum). *Vat dyes*, such as indigo, need to undergo a transformation, often with some type of fermentation process, to change the chemical constituents into a soluble state so that it can be used as a dye.

Dyes can also be categorized according to their primary chemical components, such as anthraquinones (for example, MADDER, COCHINEAL, and other insect dyes); TANNINS or polyphenols (*Quercus* oaks, cutch, sumac); flavinoids (weld, fustic, rhamnus berries, and various redwoods); carotenes (saffron, turmeric, barberry); and indigotins (various INDIGO plants, SHELLFISH PURPLES) (see Introduction, figs. 5–7). Within these chemical classes, each natural dyestuff has its own characteristic coloring compound, generally species-specific. Madder, for example, contains both alizarine and purpurin, while *Relbunium* (a related South American madder-type dyeplant) contains only purpurin. Cochineal is primarily carminic acid, while the

colorant in KERMES, another insect dyestuff that produces a color very like that of cochineal, is kermesic acid. Modern testing procedures such as High Performance Liquid Chromatography (HPLC) allow the precise identification of dyes in ancient and historic textiles (Leona, 2009).

See also SYNTHETIC DYE.

EMBROIDERY

Created with a threaded needle, *embroidery* is used to embellish a fabric ground. It can be done in a number of ways, using many types of stitches. *Straight running stitch* follows a forward movement, above and below the fabric surface. *Backstitch* floats over the surface, returning midway back for the next stitch. *Satin stitch* creates a smooth surface of long, parallel floats anchored by stitches at each end. *Couching stitch* floats over the surface with small tacking stitches holding the thread down at intervals. *Cross-stitch* forms two sets of diagonals that cross on the front surface. *Chain-stitch* creates anchored loops within loops. *Knotting* forms small decorative knots on the fabric surface.

Many variations exist on these and other stitches, used singly or in combination. Embroidery stitches often cover the entire surface of the ground cloth and are

EMBROIDERY
Border fragment (detail), Peru (Paracas culture), third–second century B.C. Camelid hair, 27.9 × 165.1 cm (11 × 65 in.). Gift of George D. Pratt, 1933. MMA 33.149.93. Image © The Metropolitan Museum of Art. Embroidery stitches (backstitch over four to six threads and back two) regularly cover the entire plain weave ground cloth.

generally intended to be seen on one face only. Sometimes stitching encases thick support elements, such as cotton roving, carton, or leather strips, forming three-dimensional embellishments; this is called *raised-work* embroidery.

Embroidery, unlike WEAVING, affords the craftsperson or artist an unrestricted design approach; however, most embroidery does follow some type of design template or pattern guide. Some cultures practiced systematic, counted embroidery, in which stitching follows the WARPS and WEFTS of the ground cloth in precise order. For example, Peruvian artisans used counted stitching—passing over four threads and back two, row after row—to create the elaborate iconography that covers the wide borders of the famous Paracas mantles (200 B.C.–A.D. 100) and mimics a woven structure. Embroiderers in Elizabethan England used a simple backstitch to cover their linen-scrim ground cloth completely with minute stitches in row after row of fine SILK threads. Some embroiderers, however, have used a less constrained approach, stitching freehand in a more design-driven way, as in the embellished VELVET door curtains or portieres of Candace Wheeler (1827–1923), masterpieces of the nineteenth-century Aesthetic Movement.

FELT

Felt and appliqué carpet (detail), Pazyryk culture (Pazyryk Barrow no. 5, excavations of S. I. Rudenko, 1949), Altai region, Pazyryk Boundary, Valley of the Bolshoi Ulagan River, fifth–fourth century B.C. Wool. St. Petersburg, Hermitage Museum 1687/94. © The State Hermitage Museum. Photo: Vladimir Terebenin, Leonard Kheifets, Yuri Molodkovets.

FELT

A nonwoven fabric made by agglomerating FIBERS together using pressure and usually hot liquid. WOOL fiber, and particularly sheep's wool, is best suited to this process due to the characteristic scales on the fiber's outer surface, which are visible under microscopy (see Introduction, fig. 15). When moistened, the scales swell, allowing the fibers to attach to one another as they are pressed and molded together, forming a solid mass.

Felt can be made in large sheets that are relatively lightweight but have their own physical integrity; such sheets are used, for example, among the nomadic peoples of Central Asia for the flooring and walls of their tents (sometimes called yurts). Felted garments, such as boots, mittens, and cloaks, are durable and extremely warm. Felt is associated with many ancient cultures. Some early examples of felt garments include the white head covering of a female mummy excavated from Xiaohe in Western China (ca. 1800 B.C.) and a polychrome felt carpet found with the Pazyryk burials of ca. 400–300 B.C., now in the Hermitage Museum.

FELTING

A process to raise a napped surface on a woven fabric, usually with a combination of hot water, abrasion, and repeated physical agitation (beating). *Felting*, sometimes called *fulling*, was used primarily on woolen cloth to form a dense, brushed surface, as in the TRADE CLOTH produced in England, Spain, and the Netherlands.

FIBER

The basic constituent of textiles. Technically, *fibers* are long-chain molecules; they can be short or long, straight or naturally twisted, and soft or hard, depending on their origin and function within their source. Fibers in their natural state are often bound up with other substances that must be removed in order to prepare the fiber for SPINNING: plant fibers may be bundled together with lignin, for example, and silk must be separated from *sericin*, a gelatinous substance also known as *silk gum*. Some fibers can be matted together and spun, like cotton, while others are unwound from their natural forms, as silk from its cocoon. The type of fiber used in creating a textile determines many of its resulting properties, such as warmth, sheen, softness, or stiffness.

Natural fibers are derived from a variety of sources. *Animal fibers* include hairs such as sheep's WOOL and *mohair* (from goats) and extrusions such as SILK. Plant fibers include seed hairs, such as COTTON; leaf fibers, such as *sisal*; and BAST FIBERS such as *flax*. There are also mineral fibers, such as asbestos, which have industrial uses.

Synthetic fibers—those that do not occur in nature—have been produced since the end of the nineteenth century from both natural and man-made materials. Rayon, nylon, and polyester are among the most commonly used in the textile industry.

FIELD

The central area of design, as in a carpet, generally bounded by borders.

FIGURED

A descriptive term for complex fabrics with repeating woven designs, often containing images of people or animals, such as those from Syria, Iran, and Egypt in the fifth through tenth centuries; from early medieval Europe; and from Byzantium in the eleventh through twelfth centuries. The terms *figured silk*, *figured samit*, and *figured damask* all denote fabrics whose designs are woven on complex LOOMS with some type of patterning mechanism. See also SAMIT, DAMASK.

FLAX See LINEN.

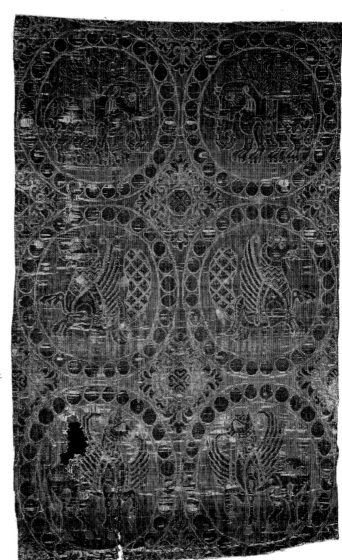

FIGURED
Compound twill, Spain, eleventh–twelfth century. Silk, 51.2 × 32.6 cm (20³⁄₁₆ × 12¹³⁄₁₆ in.) Gift of John Pierpont Morgan. CH 1902-1-222. © Cooper-Hewitt, National Design Museum, Smithsonian Institution / Art Resource, NY. Photo: Scott Hyde. Rows of pearl roundels inscribe elephants, winged "hippocamps," and winged lions.

FLOAT WEAVE

A WEAVE STRUCTURE in which elements (either WARPS or WEFTS, or both) are unbound for extended areas in the design and float over the surface. These elements are generally SUPPLEMENTARY to the weave structure.

GAUZE

In common parlance, any sheer, lightweight fabric, but true *gauze* is a WEAVE STRUC-TURE in which individual warp yarns cross over adjacent warp yarns and then cross back into their original positions, held in place by weft yarns. They generally follow a PLAIN WEAVE structure. The areas of crossed warps result in small, visible openings in the cloth, and these openings form the design areas. Some cultures weave gauze with patterns formed by juxtaposing areas of gauze crossings with areas of solid plain weave. Simple gauze involves the crossing and re-crossing of the warps. Complex gauze may involve a series of warp crossing sequences, transposition over multiple warps, and utilizing multiple weft passes. These may result in larger "holes" or *openwork* patterns formed by the multiple crossings.

To weave gauze, a special device on the LOOM is required to lift and cross the warp yarns, diverting them from their main pathway. In Peru, gauze is woven

Gauze

Textile fragment (detail), China, eighth century. Silk, gauze weave, 108 × 42.5 cm (42½ × 16¾ in.). Purchase, Gift of William Rockhill Nelson Gallery, 1950. MMA 50.148a. Image © The Metropolitan Museum of Art. Photo: author. The openings in the fabric are created by warps crossing over in one direction and then crossing back into their original place, leaving a space in between.

on backstrap looms, and examples dating to the tenth century A.D. have been preserved. In other parts of Central and South America, including Guatemala and parts of Mexico, gauze weave is still being produced. In Japan, examples of gauze weave from the sixth century A.D. are conserved in the Shōsōin, the royal treasure house in Nara.

Gold thread See METALLIC YARN.

Ground

From a design perspective, the *ground* is the background area of a pattern. The term may also be used to describe the base fabric on which EMBROIDERY is stitched.

Ground weave

In a COMPOUND WEAVE, the *ground weave* is the base structure, which generally has a contrasting pattern weave. Ground weave has its own sets of WARPS and WEFTS.

Gum arabic

Used as a binding medium for painting with pigments and for surface application of dyes onto fabric. *Gum arabic* is a natural product derived from tropical and subtropical acacia trees, especially the African species *Acacia nilotica* and *Acacia senegal*. It is water-soluble and has a certain tack or stickiness. For textile applications, gum arabic is sometimes mixed with a MORDANT or DYE to act as a thickening agent, so that the mixture can be applied to the surface of the cloth. It is also used in the making of Indian CHINTZ. See also PRINTING.

HEADER

The first and last sections of weaving on a WARP. The *header* can be minimal, composed with only one or two WEFTS, or it can extend for several inches; sometimes it is woven with heavier YARNS than the rest of the textile. Establishing a header at the beginning of weaving secures the position of the warp yarns on the LOOM. As the warps are often tied in groups onto the loom bar or front beam, with each pass of the first few wefts the header evens out the spacing of the warp, helping to create and maintain the proper width of the woven cloth for its entire length.

HEDDLES

Heddles, usually made of string or metal, are essential to WEAVING on a loom. Individual WARP yarns pass through the heddles, which are organized according to WEAVE STRUCTURE and pattern. They are often attached to a series of sticks or holding devices called *shafts*, so that they can be lifted or lowered uniformly in groups to create the weaving SHEDS or openings that enable fabric to be woven. They may be semipermanent fixtures on a loom or may be made by hand after the warp has been laid, depending on the type of loom. See LOOM.

HEMP See BAST FIBER.

HOOKED RUG

Popular in American folk tradition, the *hooked rug* is made of either cut strips of fabric (often recycled from garments) or YARN. A hook is used to pull the strips or yarn through a canvas ground, forming a looped or raised surface.

HOOKED RUG

Rainbow rug, ca. 1860. Lucy Barnard, American (Dixfield, Maine). Wool, 152.4 × 73.7 cm (60 × 29 in.).
Salisbury-Mills Fund, 1961. MMA 61.47.3. Image © The Metropolitan Museum of Art.

IKAT

A RESIST-DYEING technique in which YARNS are tie-dyed before they are woven into cloth. The term derives from Indonesian *mengikat*, meaning "to tie" or "to bind" (Gittinger, 1982). The yarns are first laid out and measured according to the length and width of the final cloth dimensions, the design is marked, and the yarns are carefully bundled into groups and wrapped according to the design. The bundled yarns are then immersed in a series of dyebaths; at each stage of the process, parts of the bundle are wrapped in dye-resistant material and other parts left exposed, so that only the exposed areas absorb the dye. Repeated wrapping, dyeing, and unwrapping through multiple dyebaths results in yarns polychromed to construct the design. When dyeing is complete, the yarns are placed on the LOOM and woven with careful attention to aligning the pattern. *Ikat* dyeing and weaving requires skill and precision in planning the placement of the designs on the unwoven yarns, and in calculating the take-up that will occur during WEAVING so that patterns are clear on the completed woven cloth. Ikat can be done on WARP or WEFT, or both. In *double ikat*—also called *Patola* after the Indian region that is renowned for its production—both warp and weft yarns are resist-dyed to create patterns prior to weaving. It requires exceptional skill in planning to get the intended pattern to form perfectly as the warp and weft are interlaced.

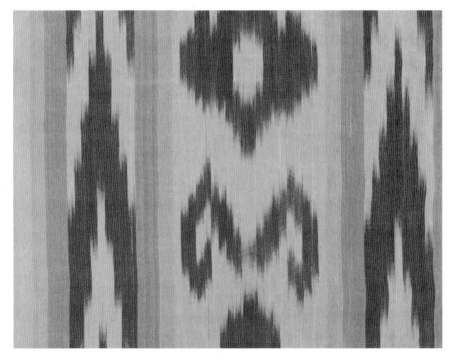

IKAT

Warp ikat fragment, Central Asia, eighteenth century. Silk, plain weave, resist-dyed (ikat), 25.4 × 35.6 cm (10 × 14 in.). Gift of the Carnegie Corporation of New York, 1930. MMA 30.10.13.
Image © The Metropolitan Museum of Art.

INDIGO

A blue dye, whose color compound, *indigotin,* is found in leaves of tropical and subtropical plants of the genus *Indigofera.* Indigo-bearing plants are found naturally in India (*I. tinctoria*), Africa, and the Americas (*I. suffruticosa*). In Europe, a plant called woad (*Isatis tinctoria*) contains the indigotin colorant. All of these plants, from a number of different genera and species, yield the same dye-stuff—*indigo.*

Indigo is a vat dye (see DYE). It is extremely lightfast and has been used since prehistoric times. *I. tinctoria*, the Indian species has the highest color content and was much sought-after by European producers. Indigo is, however, difficult to use, requiring a series of chemical processes before the dye will take to cloth. Traditionally, the crushed indigo leaves were fermented to transform the initial blue liquid into a chemically reduced state, in which it turns a yellowish green color. At this stage, the YARN or cloth can be immersed in the vat to soak up the colorant. Upon oxidation—by exposing the FIBERS to sunlight and air—the yellowish green turns blue. The indigo blue dye compound is insoluble in water; fermentation and the

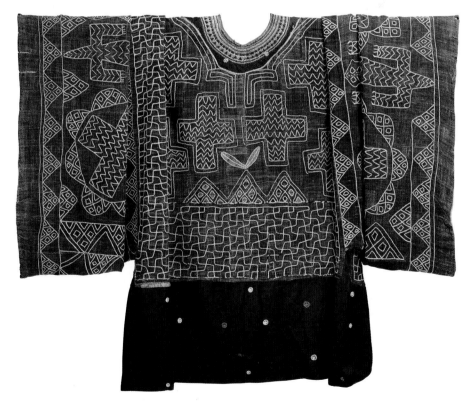

INDIGO
Prestige gown, Cameroon (Grassfields region), nineteenth–twentieth century. Cotton and wool, 219.1 × 114.3 cm (86¼ × 45 in.). Purchase, Dr. and Mrs. Sidney Clyman Gift and Rogers Fund, 1987. MMA 1987.163. Image © The Metropolitan Museum of Art.

INDIGO

Heaven, dyed hanging from the series *Storie della Passione*, Italy (Genoa), sixteenth–eighteenth century.
Woad-dyed hemp, 300 × 400 cm (118 × 119 in.). Private collection, located in Museo Diocesano, Genoa,
Italy. Photo courtesy of the Ministero dei Beni e delle attività Culturali Soprintendenza per i Beni
Storici, Artistici ed Etnoantropologici della Liguria / IKONA.

addition of a strong alkali—traditionally consisting of stale urine—temporarily renders the dyestuff soluble. It reverts to its insoluble form in the fiber, creating a permanent color.

The dye can be made from fresh leaves from the plant, or it can be extracted and dried as a cake for later use, which greatly enhanced its value as a trade commodity. Indigo could travel vast distances in cake form and then be redissolved, reduced, and oxygenated, for use by dyers in other regions. Indigo blue is perhaps best known as the dye of DENIM cloth for blue jeans, but it has been used by many cultures throughout the world for its strong, enduring color. Scientists in the nineteenth century identified the chemical structure of indigotin, ushering in a new age of synthetic indigo blue.

INTERLACE

The interconnection and movement of YARNS or elements as they form structures in pathways going over and under each other.

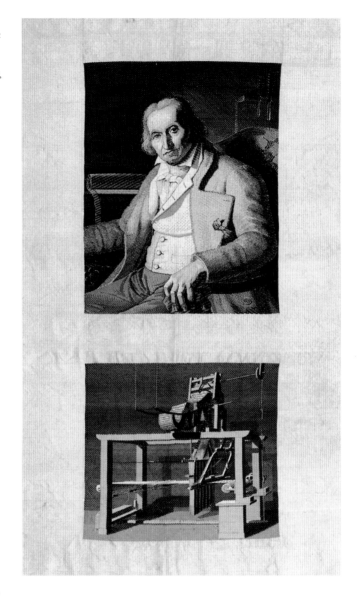

JACQUARD LOOM

A *Jacquard loom*, or more precisely, the jacquard attachment to a LOOM, is a mechanism to automate the raising and lowering of individual WARP threads in order to weave complex designs, a task that was previously done laboriously by hand. The mechanism is governed by a series of punched cards, forerunners of the technology that produced the computer. Though a number of innovators had been working to create such a loom in the eighteenth century, it was Joseph-Marie Jacquard (1752–1834) who acquired the patent in 1801 and is credited with its creation. It revolutionized the weaving industry, and its principle is still in use today, though the automation is now computer-driven.

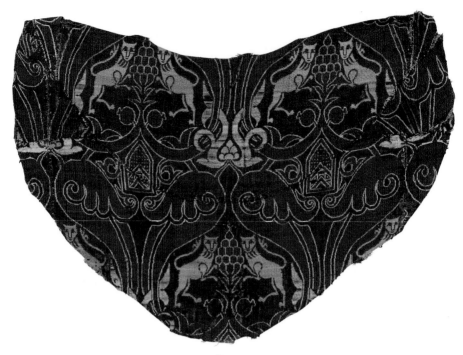

KERMES

Textile fragment with confronted crowned lions, Spain (Nasrid period), fifteenth century.
Lampas weave silk colored with kermes (red) and other dyes, 26 × 37.1 cm (10¾ × 14⅝ in.).
Gift of Clara Waldeck, in memory of her husband, Hans Waldeck, 1981. MMA 1981.372.
Image © The Metropolitan Museum of Art.

KERMES

Kermes vermilio, or kermes dye insect, was a primary source of red DYE for most of Europe prior to the sixteenth century. Eclipsed by imported COCHINEAL from the Americas after the 1520s, *kermes* had been highly regarded for its deep crimson red colorant, formed of kermesic acid, since prehistoric times. Collected from the kermes oak (*Quercus coccifera*), a shrubby evergreen that grows in the Mediterranean region from southern Spain to Crete, kermes dye was referred to in the first century A.D. by Pliny the Elder, who noted in his *Geographica* that it was a tribute item from Spain to the Roman Empire. In medieval Europe, kermes was a precious commodity, and in 1464 Pope Paul II authorized its use for official cardinal red, replacing the purple dye that had been used in prior centuries (see Cardon, 2007).

KESI

Chinese SILK tapestry, woven with slit joins. The fine pictorial renderings achieved by weaving silk threads in TAPESTRY WEAVE have sometimes been likened to woven paintings.

KILIM See RUG WEAVING.

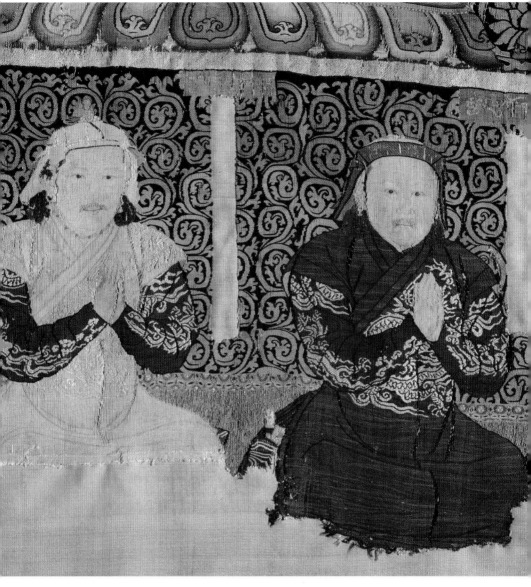

Kesi

Mandala of Yamantaka-Vajrabhairava (detail), China, Yuan dynasty (1271–1368), ca. 1330–32. Silk tapestry (kesi), overall 245.5 × 209 cm (96⅝ × 83⁵⁄₁₆ in). Purchase, Lila Acheson Wallace Gift, 1992. MMA 1992.54. Image © The Metropolitan Museum of Art. The realistic tapestry-woven portraits from the lower left corner of this large mandala depict Tugh Temür, Mongol emperor from 1328 to 1332, and his brother Qoshila, who reigned briefly in 1326 as Emperor Mingzong. Some details are woven with flat metal strips on paper and used in a three-dimensional wrapping technique, which can be seen in the dragon design on the sleeves of the tunics worn by the two dignitaries.

KNITTING

Looped construction formed in rows of open loops-into-loops, using two or more needles, *knitting* is a technique for making garments and edgings with variations on the ways in which the loops are formed. Traditional knitting uses an open loop; ancient cultures produced similar items in a different way, crossing the loops as they form into one another, likely using a single needle or other method. While the practice of cross-looping was an ancient art, found in Dura Europos, Syria, and in Peru from around the third century (see LOOPING), knitting as we know it developed somewhat later. It was practiced in twelfth- to thirteenth-century Egypt, as evidenced by the blue and white sock found in Fustat, pictured here.

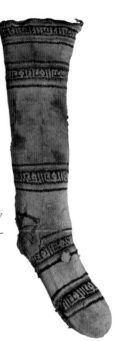

KNITTING

Sock, Islamic Egypt (Fustat), twelfth–thirteenth century. Wool, 26.7 × 12.7 cm (10½ × 5 in.). Rogers Fund, 1927. MMA 27.170.96. Image © The Metropolitan Museum of Art.

KNOTTED PILE

Used to create three-dimensional surfaces, especially in carpets and other furnishing fabrics. It is produced with a woven WARP and WEFT, and a SUPPLEMENTARY pile weft. The PILE weft begins as a continuous YARN, forming loops that are subsequently cut to create the pile. The loops are secured in place by the weft forming the GROUND WEAVE, which alternates with rows of pile. Although called *knotted pile*, it is not actually knotted as it is not tied to itself; rather, the weft yarns wind around one, two, or three warps, entering in between pairs of warps and exiting either between

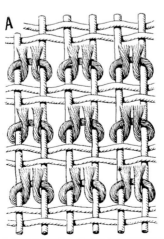
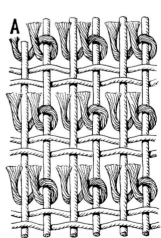

KNOTTED PILE

Symmetrical (Turkish) and asymmetrical (Persian) knots after drawings by C.E.C. Tattersall in Victoria and Albert Museum, *Notes on Carpet-Knotting and Weaving,* London, 1920 (1949 reprint), Plates Ia, IIa.

the same or the next pair. The route that the yarn follows to make the loop, as it travels around the warps, is either symmetrical or asymmetrical.

Symmetrical knots are generally formed wrapping around two warp yarns (called *Turkish* or *Ghiordes knots*) or a single warp (called *Spanish knots*), with their beginning and ending tails exiting out between two adjacent warps.

Asymmetrical knots (known as *Persian* or *Senneh knots*) are formed over two or three warps and have beginning and ending tails exiting between different warps. These knots are described as either "left opening" or "right opening," depending on the original direction that the yarn was wrapped.

See also RUG WEAVING.

KNOTTED PILE
The Anhalt carpet, Iran, mid-sixteenth century. Cotton warp, silk weft, wool pile, asymmetrically knotted, 806.5 × 424.2 cm (317½ × 167 in.). Gift of Samuel H. Kress Foundation, 1946. MMA 46.128. Image © The Metropolitan Museum of Art. The carpet is made of Persian or asymmetrically knotted pile.

LACE

Cravat end, France, late 1690s. Linen needle lace, 28.5 × 41 cm (11¼ × 16⅛ in.). Bequest of
Richard Cranch Greenleaf in memory of his mother, Adeline Emma Greenleaf. CH 1967-50-18b.
© Cooper-Hewitt, National Design Museum, Smithsonian Institution / Art Resource, NY.
Photo: Andrew Garn.

LACE

Decorative *lace* is appreciated for its lightweight, delicate character. It originates
from two main techniques—bobbin work and EMBROIDERY or needle lace (Levy,
2003). *Bobbin lace*, made in Italy beginning in the sixteenth century, utilized indi-
vidual threads anchored to a pillow and wrapped around a series of bobbins, which
could be worked by hand into a number of different patterns and structures. *Nee-
dle lace*, specifically *cutwork embroidery*, utilized a needle and thread worked on a
GROUND fabric and sometimes involving the removal of parts of the ground. These
two methods were employed to create a wide variety of lacework used in trim-
mings, garments, and personal items. Lace became extremely popular, especially
in the sixteenth and seventeenth centuries, and spurred the textile economies of
Europe. Flanders, Italy, France, and Spain all produced high quality lace, which
was prized throughout the region and exported to the Americas and around the
world. Costly hand-made products were gradually supplanted by machine-made
lace and nettings beginning in the late eighteenth century, as new industrial equip-
ment facilitated the necessary specialized processes.

LAMPAS

A COMPOUND WEAVE used to produce luxurious figured SILKS, often, but not always, incorporating a surface of gold or silver thread, beginning around the eleventh century in Syria and Iraq, and notably in Spain. Technically, *lampas* is a combination of two structures formed from PLAIN WEAVE, TWILL, and/or SATIN bindings, in various combinations. Unlike its predecessor, SAMIT or compound twill, which has a single, continuous face, lampas juxtaposes two faces created with these structures—generally a WARP-FACED weave for the GROUND structure and a WEFT-FACED weave structure for the pattern—creating a three-dimensionality to the fabric surface that enhances the design. As a fabric structure, it was particularly suited to incorporating stiff and somewhat rigid gold threads so that they could be bound into the fabric without compromising design details.

The development of the lampas structure occurred within the medieval silk-weaving tradition, particularly in the thirteenth century, fostered by the interchange between East and West with the trade in Mongol fabrics and the spread of Arab silk-weaving to Mudéjar Spain and thence to Italy. The origins of lampas weave and its related LOOM developments and patterning mechanisms remain subjects of scholarly investigation (Watt and Wardwell, 1997; Desrosiers, 2004). It continues to be used today in the textile industry.

LAMPAS

Textile with phoenixes, lotuses, and tree peonies (detail), Central Asia, Yuan dynasty (1271–1368), thirteenth century. Silk and metallic thread, 66 × 69.8 cm (26 × 27½ in). Anonymous gift in honor of James C. Y. Watt, 1989. MMA 1989.191. Image © The Metropolitan Museum of Art. The lampas is constructed with a warp-faced plain weave ground (pink) and a weft-faced plain weave pattern (gold).

LENGTH

A length of cloth is generally a fixed dimension, established culturally, and tends to conform to the measurement of the WARP that was put onto the LOOM for WEAVING.

LINEN

A BAST FIBER produced from the flax plant (*Linum usitatissimum*), an annual. *Flax* grows in temperate climates and is native to Europe. Once the plants are harvested, the linen fibers (phloem located in the tall stalks) must be separated from the rest of the plant material, a process called *retting*. Retting involves soaking the stalks in water—traditionally, in shallow ponds or still water—and allowing bacteria in the water to break down the woody materials that facilitates the removal of the usable fibers. Individual linen fibers can be up to 36 inches in length and have characteristic strength and luster. Viewed under the microscope, the linen fiber may be identified by its distinctive x-shaped nodes that are visible in longitudinal section. The natural function of the phloem within the plant is to transport water, and fabrics made of linen inherit this quality, wicking moisture and remaining cool to the touch. Often used for undergarments and bedding, linen fabric ameliorates the effects of heat on body temperature. See also BAST FIBER.

LOOM

An instrument that facilitates WEAVING by holding the WARP yarns with some degree of tension (either fixed or variable), enabling the weaver to lift or lower selected warps to create the weaving SHEDS (openings) for WEFT insertion. In its most basic form, a *loom* is a stick or bar upon which the warp threads are fastened. Looms, in many formats, hold the warp either vertically or horizontally and can have simple or complex elements to aid the weaving process. Essential features of a loom are the HEDDLES, which allow the weaver to lift or lower warp threads during weaving. Made of string or metal, and either permanently part of the loom or constructed for each new warp, they are arranged in sets onto heddle cords or rods or onto shafts, or harnesses (component structures of some looms) according to the WEAVE STRUCTURE. Some simple looms do not use heddles but rely on a stick (called a *shed rod*) or the weaver's hands to lift the individual warps. All looms use some type of beater, comb, or stick to pack the wefts as they are woven.

There are many types of looms. *Backstrap* or *body tension loom* has two loom bars holding the warp. One bar is attached to a stationary device, such as a tree, and the other to a belt around the weaver's waist. The weaver's movement backward and forward pulls or eases the tension, enabling the weaver to open the sheds for weaving and to insert the weft. These looms, used in Central and South America and Southeast Asia, are created anew, using its component parts, each time the weaver begins a textile and lays on the warp.

Fixed tension or *ground loom*, often a horizontal ground loom, is composed of four stakes (two each to hold the loom bars in place) or, alternatively, set up as a rigid frame. This type of loom holds the warp in rigid tension. In the Andes, it is

used to weave densely packed WARP-FACED weaving with YARNS that have been given extra twist so that while the warp is held rigidly, there is some flexibility or give to the yarns, allowing the weaver to lift them to produce the pattern. Like the backstrap loom, this loom breaks down to its component parts after each textile is completed.

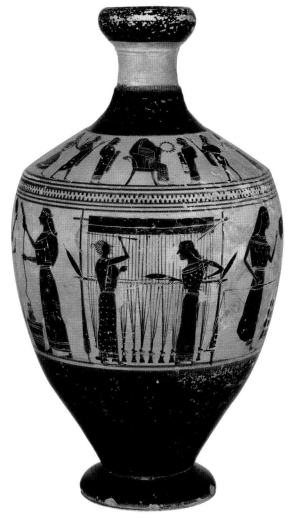

LOOM
Black-figure lekythos, attributed to the Amasis Painter, Greek (Attic), ca. 550–530 B.C. Terracotta, h. 17.15 cm (6¾ in.). Fletcher Fund, 1931. MMA 31.11.10. Image © The Metropolitan Museum of Art. The two women stand at the warp-weighted loom: one creating the shed, the other inserting the weft.

Warp-weighted loom is a vertical warp loom, with the warps suspended from an upper cross bar and held under tension by a series of stone or ceramic weights tied to groups of yarn at the lower ends. Weaving proceeds from top to bottom. This type of loom was used by Egyptian, Greek, and early Northern European cultures, from Neolithic, Bronze Age, and Iron Age periods, where loom weights, though no looms, have been excavated from sites such as Lisht (Egypt), Troy, and Hallstatt. Fabrics produced on these looms are often wide and have distinctive SELVAGE or edge treatments. Warp-weighted looms were also used in North America to produce

twined fabrics (using pairs of twisted wefts to create the colorful surface), such as those of the Chilkat weavers of Northwest Tlingit tribe.

European treadle loom is constructed of heavy wooden beams that contain working mechanisms and movable parts. It holds the warp on two rollers, mounted at the front and back of the loom apparatus. The warp is threaded through heddles that are attached to rigid shafts or *harnesses*, which are counterbalanced to allow for movement. These are tied to foot treadles with cords, enabling the weaver to lift and lower them to create the weaving sheds. The weaver sits or stands at the front of the loom to manipulate the treadles by foot, and throws SHUTTLES containing the weft yarns back and forth at each change of the sheds. The *reed and beater*, a comblike device to maintain the spacing of the warps during weaving, is then pulled by hand back and forth to pack the weft yarns. Long lengths of fabric could be woven on the loom. Variations on this treadle loom were used worldwide.

Complex looms, such as the DRAWLOOM or the JACQUARD LOOM have additional components that aid in the lifting and lowering of individual threads in sequence to facilitate weaving repeated detailed designs.

Specialized looms for TAPESTRY WEAVING were used by many cultures. In Europe, two loom types developed as either horizontal (*basse lisse*, meaning "low warp") or upright (*haute lisse*, meaning "high warp") looms. Tapestry weaving requires that the warp be held especially taut, and most tapestry-weaving cultures developed looms that allow the warp to be straight or extended and not rolled, as much as possible, so that the design is visible during weaving. As a result, these looms require a lot of space and the weaver may accommodate the taut warp requirements by moving vertically on a scaffolded seat, rather than rolling the warp down for the working process. Tapestry looms are generally very wide relative to other loom types.

LOOPING

Looping techniques utilize a single long YARN or element that loops around and crosses itself to create a number of different formations. In some methods, the loops are formed one into the other, as in KNITTING, while in other methods, loops are formed around a support element or yarn, as in some types of basketry or crossed-looping. Loops can be formed in straight rows with the craftsperson working back and forth or in tubular fashion and sometimes are stitched as EMBROIDERY onto a cloth surface (as in NEEDLELOOP EMBROIDERY). When worked loosely, as in bags or hammocks, loop structures are very flexible. When worked tightly, the loops form solid entities that hold their own form; this technique is used to create baskets and other types of containers or for decorative edgings. The famous Peruvian "Paracas Textile" depicting shamanic and ceremonial figures surrounding a ritual cloth, from the first to third century A.D., is constructed of crossed-looping both with and without a support element, and with and without a ground structure. It is one of the most notable examples of the fine art of looping.

LUSTER

Gloss or sheen of a textile or FIBER created through the reflectance of light on its surface. Long fibers with uninterrupted surfaces, such as SILK, have a high luster, while COTTON, with its short and twisting fibers, has low luster. Woven fabrics may have luster depending on both the fiber and the WEAVE STRUCTURE. SATIN, for example, with its relatively long float, was devised to produce woven silk fabric with a high luster. PLAIN WEAVE fabrics, even those made with silk yarns, tend to have a lower luster. (See TAFFETA.)

MADDER

A dyestuff produced from the roots of plants in the family Rubiaceae. The source most widely exploited in Europe is common or dyer's madder (*Rubia tinctorium*); different but related species, both wild and cultivated, are also found in Asia, India, Africa, and the Americas. *Madder*, a MORDANT DYE, produces reds that tend to have an orange hue but may range from deep scarlet to purple, depending on the dyeing process. The primary coloring component of madder is *alizarin*, with secondary compounds of *purpurin* and *pseudopurpurin*. Madder takes readily to SILK and WOOL, but special procedures are needed to make the dye bond with COTTON and LINEN (see TURKEY RED). Madder has been in use for thousands of years; textiles dyed with madder have been recovered from the Indus Valley (Mohenjo-Daro), dating to 3000 B.C., and from Egypt, dating to the second millennium B.C.

METAL LEAF
Noh costume
(surihaku) with Chinese
bellflowers, Japan, Edo
period (1615–1868),
eighteenth century. Gold
and silver leaf on silk
satin, 173.4 × 145.4 cm
(68¼ × 57¼ in.). Joseph
Pulitzer Bequest, 1932.
MMA 32.30.5. Image
© The Metropolitan
Museum of Art.

METAL LEAF

Thin sheets of gold or silver beaten to a thickness of approximately 0.1 micrometer.
Gold and *silver leaf* may be applied directly onto textiles, using a natural adhesive or
may be applied to a substrate to make METALLIC YARNS.

METALLIC YARN

Metallic yarn can be made in a number of ways. Thin sheets of pure metal—gold,
silver, gilt silver, or copper—can be cut into strips and used as flat elements. Some
of the earliest examples of textiles with metal (usually gold) yarns are made this way.
But the majority of metallic yarns are composed of a very fine METAL LEAF adhered
to a substrate, called a *lamella*, made of paper, leather, animal gut, or membrane.
These metal-leafed lamellae can then be used in textiles either as flat strips or wound
around a core yarn.

METALLIC YARN
Textile fragment with birds, leaves, and arabesques, Spanish or Italian, fourteenth century. Silk and metal thread, 61 × 21.6 cm (24 × 8½ in.). Fletcher Fund, 1946. MMA 46.156.43. Image © The Metropolitan Museum of Art. Photo: author. The metal yarn is composed of gold leaf on a fine leather substrate, wrapped around a white core yarn that may be linen or cotton.

The use of precious metals on substrates varies by culture and region. Chinese metallic yarns, for example, generally use a mulberry-paper substrate, with metal leaf adhered to one or sometimes (exceptionally) both sides; the yarns are then used for EMBROIDERY and WEAVING. The substrate used for Western European metallic threads include membranes from animal intestines (from goats, for example) or leather, which must be specially prepared and softened. After the metal is applied, the substrate is cut into thin strips and wound around a core yarn, sometimes leaving space between rotations to reveal the core underneath. The core yarns are often SILK but can also be COTTON or LINEN. Especially when made of silk, the core yarns are often first dyed to enhance the color of the metal: for example, those with gold or gilt-metal surfaces often use a yellow- or orange-dyed yarn, while silver often uses white.

Archaeologists have found fragments of metallic yarns in France dating to the second century B.C. and in Dura Europos, Mesopotamia, from around the third century A.D. (Desrosiers, 2004; Pfister and Bellinger, 1943). In Asia, metallic yarns have been used since the eighth century, most notably by Mongol weavers in the thirteenth–fourteenth centuries. Their renowned *cloth of gold* was traded to the West and appears in Italian paintings of the *quattrocento* as the fabric of choice for Florentine angels (Monnas, 2008). Metallic yarns were used extensively in the luxury textiles of Europe—the silk BROCADES, VELVETS, and TAPESTRIES—a fashion fueled in part by the quantities of gold and silver arriving from the New World. While much of the metal found in European textiles came from the mines of Mexico and South America, beginning in the sixteenth century, it was rarely used for weaving in the Americas itself during the same period.

MOIRÉ

A finishing technique for patterning fabric. The cloth is laid against a wooden panel, plate, or metal roller with inscribed lines, and heat and pressure are then applied. The result is a pressed design, often of parallel lines, referred to as a *water* pattern. *Moiré* is found on European silks (sometimes called *watered silks*) from the seventeenth century onward. It was also used on woolens in England, referred to as *calendared*, and can be seen in furnishing fabrics and QUILTS.

MOIRÉ
Nadar (French, 1820–1910), *George Sand (Amandine-Aurore-Lucile Dudevant)*, 1861–69. Albumen print, 24.13 × 18.42 cm (9½ × 7¼ in.). JPGM 84.XM.436.91. The author George Sand is posed wearing a moiré or watered silk gown.

MORDANT

Deriving its name from the term "to bite" in ancient Greek, a *mordant* is a substance (usually a metallic salt) used in the dyeing process to bond the DYE and the FIBER together. A large category of dyes, referred to as *mordant dyes*, including MADDER, COCHINEAL, weld, and others, require mordants. Common mordants include alum (aluminum sulfate), tin (stannous chloride), iron (ferrous sulfate), and chrome (potassium bichromate); these may be used on fibers, yarns, or fabrics prior, during, or after the materials are immersed in the dyebath. The mordant can affect the color; for example, iron turns crimson-red cochineal a bluish purple color, while tin brightens it to a brilliant orange (historically called *fiery red*). Alum, the most universal mordant, was produced in many cultures by burning leaves of particular plants into ash. The Romans, however, mined *alunite*, a mineral form of alum, and exported it throughout Europe. See also DYE.

NATURAL DYE

Dye from plants, animals, or minerals, as distinct from synthetic dye (see DYE).

NEEDLELOOP EMBROIDERY

Anchoring the beginning and ending of rows of loops into a fabric ground enables the embroiderer to create shaped designs from the areas of loops. As the loops are attached to but not solidly formed onto the GROUND cloth, the embroiderer can expose the background by enlarging the size of the loops. Chinese embroiderers, especially those of the Yuan period (1271–1368), placed sheets of gold foil between the ground fabric and the *needleloop embroidery*, so that the gold glittered subtly in the light, reflecting through the openwork loops.

OBVERSE

The front side of a textile. (See Introduction, fig. 13.) The opposite side is called the REVERSE.

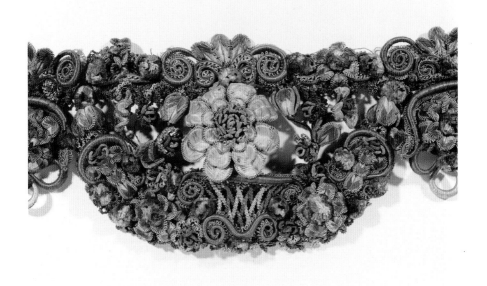

PASSEMENTERIE

Elaborately constructed braided and corded trimmings and tassels, gimps, edge
bindings, and cords used in curtains, upholstery, and other furnishings. The name
derives from the French *passement*, "to braid."

PATCHWORK

Construction made by stitching (by hand or sewing machine) various pieces of
cloth together. *Patchwork* is used by most cultures, originating as a method to mend
and embellish garments and utilitarian items, such as bedcovers; in Japan, the word
for patched and mended items is *boro*, meaning "rags." Patchwork developed into
an art form in which decorative items are made variously out of new fabric cut to
shape, unused off-cuts from other sewing projects, or salvaged pieces from used
and worn-out items. Pieced patchwork QUILTS, for example, are often composed
of many fabrics cut into regular shapes (such as squares, diamonds, octagons, and
triangles) stitched together to form patterns. They are sometimes constructed using
a template, for example, made of paper or carton. The use of templates aids in the
construction of complex visual patterns and helps maintain the exact shape and
size of the pieces, prior to stitching together. Other patchwork designs are more
randomly assembled. Often patchwork is combined with APPLIQUÉ, QUILTING, and
other types of EMBROIDERY for embellishment. See QUILT and QUILTING.

PATCHWORK

Priest's robe, Japan, Edo period (1615–1868). Silk and metallic thread, 118.1 × 202.6 cm (46½ × 79¾ in.). Joseph Pulitzer Bequest, 1919. MMA 19.93.10. Image © The Metropolitan Museum of Art. Humble patchwork is transformed into a work of art.

Hexagon autograph quilt, ca. 1856–63. Adeline Harris Sears (American, 1839–1931). Silk with inked signatures. William Cullen Bryant Fellows Gifts. MMA 1996.4. Image © The Metropolitan Museum of Art. Note the signature of Abraham Lincoln in the center ("your friend & servant").

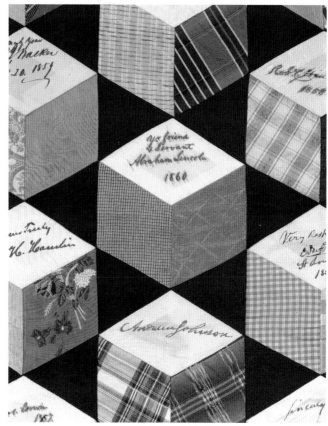

PILE

A three-dimensional surface to a textile, formed either during weaving or after, as EMBROIDERY. *Pile* is generally constructed as a loop, which can be left as a loop or subsequently cut. Woven pile can be constructed as a WARP technique (as in VELVET) or a WEFT technique (such as KNOTTED PILE carpets or industrially woven VELVETEEN). *Cut pile*, as in velvet, reveals the density of color in the cut cross-section of the tightly packed dyed yarn. Often a pile fabric—whether a silk velvet or a knotted wool carpet—has a nap or direction in which the pile lies, usually the direction opposite from which it was woven or knotted. The shade or depth of the color in a pile fabric varies with the direction of light, depending on its orientation to the nap. Pile weaves deliberately exploit this effect, while adding weight and (often) warmth to a fabric. Pile weaves appear in Egyptian looped-pile furnishing fabrics of the third or fourth century A.D., and knotted pile in carpets as early as 500 B.C. from Siberia. See KNOTTED PILE, VELVET, RUG WEAVING.

PLAIN WEAVE

A fabric structure composed of one set of WARPS and one set of WEFTS, interlacing in a rhythm of over-one and under-one. *Plain weave* is the simplest of WEAVE STRUCTURES and is used worldwide. It is used to create fabrics of many qualities and can

be woven as balanced, WARP-FACED or WEFT FACED, and a variety in between. Plain weave is sometimes referred to as *tabby*. As a structure, plain weave is the basis for other weaves such as TAPESTRY WEAVE (weft-faced plain weave with color changes), *taqueté* (a compound plain weave structure), and others. (See Introduction, fig. 2.)

PLAITING

Braiding or interlacing multiple strands of yarns. *Plaiting* connotes many different types of braiding, including *flat braiding* and *circular braiding*. Generally plaiting takes place with one set of yarns, which are fixed at one end and loose at the other, interworked across one another to form bands and cords.

PLY

A term that describes both the composition of a YARN, such as a two-ply yarn, and also the act of combining spun elements into yarns: to "ply" by respinning together. A *plied yarn* is one composed of two or more spun or plied elements, for example, two single-spun yarns respun together. This process can be repeated, for example, combining two sets of plied yarns to form a four-ply yarn, which in turn can be spun again making an eight-ply. Plied yarns, like all yarns, are described according to their *direction* of spin: they are called *S-spun* (twisted to the right) or *Z-spun* (twisted to the left). Often the direction of the each ply runs opposite that of its component elements; hence, two Z-spun single yarns may be plied in the S-direction. This would be annotated as 2Z S or shortened as 2/\. Heavy yarns and cordage (for example, those used as SELVAGE or heading cords) may be composed of three, four, six, eight, or more plys. (See SPINNING.)

POINT REPEAT See DESIGN REPEAT.

PRINTING

Repeatable application of color and design to the surface of a fabric through a mechanical or hand process. *Printing* can be done by a variety of methods and tools, including woodblock, COPPERPLATE, roller, SILKSCREEN, and STENCIL. Each type of printing has its own characteristics; the size and shape of the design unit depends on the size and shape of the printing element or elements. Hand methods, such as woodblock printing, can be applied according to taste, while more mechanical, repetitive means of color application such as roller printing, result in more rigidly regular DESIGN REPEATS.

In *woodblock printing*, designs are carved or picked out with raised pins on a block of wood, which is then impressed on the fabric with a mallet or hammer. In COPPERPLATE PRINTING, the colorant is applied to a convex engraved plate; the cloth is then run through a press. *Industrial roller printing* feeds the fabric through a series of metal rollers, creating a continuous repeating design.

The design repeat varies for different types of fabric printing. For roller prints, the size of the repeat is limited to the diameter of the roller; copperplate designs are

also of limited size, due to the physical dimension of the plates, but multiple plates were often used to complete a larger-scale design repeat. Block printing is more irregular, as it is hand applied, and can be used to produce designs with single or multiple blocks.

NATURAL DYES used for direct printing must be thickened with GUM ARABIC or some other paste. Alternatively, the design can be printed using only the MORDANT or resist paste, for subsequent immersion in a dyebath. See also CHINTZ, RESIST DYE-ING, SILKSCREEN PRINT.

QUILT

Originally used as a bedcover, a *quilt* can be made in a variety of ways. Generally speaking, it consists of a *face* or top, a *backing*, and *edging*, and often a layer of *batting* (COTTON, WOOL, SILK, or, more recently, polyester) in between. The face may be a single piece of cloth or a composite of hundreds of pieces stitched together. Edging or trim is used to complete the unit. Designs vary from culture to culture, as do the systems of assembling the various layers.

QUILTING

The stitches used to bring together layers of fabric with batting in between, *quilting* often has both functional and decorative aspects. Quilting stitches can be straight running, back or chain stitches, made by hand or by sewing machine. Often quilting is done using a frame or roller system, which holds the various layers under uniform tension to aid the quilter in her work.

RAMIE See BAST FIBER.

RESIST DYEING

A process for creating dyed designs using various types of materials to block the penetration of the DYE in the design area. *Resist dyeing* can be done before or after WEAVING. The medium of the resist can be wax, string, or wooden blocks that ensure that some areas do not absorb the color during dying.

Various resist-dyeing methods are used to create designs on woven cloth. *Paste resist dyeing*, or *batik*: a material such as a paste or wax is applied to the surface with a brush, pen, stamp, or other printing device, prior to immersing the cloth in a dyebath. After dyeing, the resist media is removed, revealing the original cloth color

RESIST DYEING
Fragment of a clamp-resist dyed textile with deer in roundel, China (Dunhuang), Tang dynasty, ninth century. Silk, 28.7 × 10.9 cm (11½ × 4½ in.). Aurel Stein Collection, 1917. London, The British Museum, MAS 874b. Image © Trustees of the British Museum. The ground of the clamp-resist dyed textile with blue deer, though now faded, was originally red, indicating that at least two dyes had been used.

RESIST DYEING

Tie-dyed tunic, Peru (Wari),
ca. 700–850. Camelid hair,
86.4 × 116.8 cm (34 × 46 in.).
Gift of Rosetta and Louis
Slavitz, 1986. MMA 1986.488.3.
Image © The Metropolitan
Museum of Art. The tie-dyed
components were originally
woven in discontinuous
warp and weft strips, dyed,
separated into units, and re-
joined into this garment.

Fragment of a kimono
(kosode) with design of
chrysanthemums and
chevron. Pattern, Japan (Edo
period), late seventeenth
century. Tie-dyeing (kanoko
shibori) and silk and metallic
thread embroidery on
silk satin, 85.1 × 35.6 cm
(33⅓ × 14 in.). Gift of
Miss Bella Mabury. LACMA
39.2.248. Digital Image ©
2009 Museum Associates /
LACMA / Art Resource, NY.

(usually white), which contrasts with the areas that absorbed the dye. *Clamp-resist dyeing*: pairs of boards are carved with concave and flat surfaces creating a design. The fabric is then clamped between the boards and dye is poured through special openings so that it penetrates only where the boards are concave. *Shibori* or *tie-dye*: Cords or strings are tightly wrapped around sections of cloth to form the resist design. Stitching can also be used.

Resist dying may also be done prior to weaving. See IKAT.

All resist dyeing processes can be repeated so that areas dyed one color can subsequently be covered with resist medium before the piece is dyed a second color. Multicolored textiles can be created through iterations of this process. See also CHINTZ.

REVERSE

The back side of a textile. The front side is called the OBVERSE. (See Introduction, fig. 14.)

RUG WEAVING

Rugs—textiles for the floor—can be made in a number of ways, including KNOTTED PILE, weft-wrapping (*soumak*), TAPESTRY WEAVE (*kilim*) or WARP-PATTERNED WEAVE, and DOUBLECLOTH. They can also be EMBROIDERED (for example, cross-stitch needlework or ragwork) or dye-painted (as in the summer carpets of India). Many of

RUG WEAVING
Knotted pile rug with confronted animals, attributed to Turkey (Ottoman period), fourteenth century. Wool, symmetrically knotted pile, 165.1 × 138.4 cm (65 × 54½ in.). Harris Brisbane Fund, Joseph Pulitzer Bequest, Louis V. Bell and Fletcher, Pfeiffer and Rogers Funds. MMA 1990.61. Image ©The Metropolitan Museum of Art.

the techniques we most associate with *rug weaving*, particularly the knotted pile, are also used to make other items, such as saddle rugs or tent hangings.

Knotted pile rugs and carpets are composed of a warp, a weft, and a SUPPLEMEN-TARY pile weft that form the knots. See KNOTTED PILE.

Flatwoven rugs made in the tapestry technique (weft-faced PLAIN WEAVE with DISCONTINUOUS wefts) are sometimes referred to as *kilims*, a term that is particu-larly associated with the rugs of tribal and nomadic cultures of Anatolia, the Cau-casus, and Central Asia. Kilims generally have open slits in between the color changes, which occur in the wefts. The French TAPESTRY workshops of the eigh-teenth century also manufactured rugs in tapestry weave, often as ensuite sets to match wall-hung tapestries.

Soumak rugs are made by a technique of weft-wrapping, in which the wefts wrap around groups of warps to cover the surface. The wrapping proceeds across the width of the carpet and creates a diagonal appearance to the surface, built up row by row, with or without a woven weft pass between rows. Changing the direction of the wrapping creates a herringbone effect.

Warp-patterned woven rugs come from a different weaving tradition and were made on different types of LOOMS (horizontal ground looms). These rugs are some-times made up of multiple narrow lengths of warp-faced and warp-patterned cloth of a number of structures, including doublecloth. Nineteenth-century *doublecloth woven rugs*, called *ingrain* carpets, were produced industrially in England. Other industrial processes have been incorporated into the production of modern rugs, which are sometimes designed as works of art.

SAMIT

A compound TWILL weave produced in Persia, Syria, Central Asia, Byzantium, and Europe from as early as the fifth century A.D. up until around the twelfth century. During this period, cloths of *samit*—luxurious patterned SILK fabrics— from the

SAMIT
The Senmurv Silk,
Iran or Central Asia,
seventh–eighth century.
Silk, compound twill,
36.5 × 54.3 cm (14½ ×
21¾ in.). V&A 8579-1863.
© Victoria and Albert
Museum, London. Said
to have been found in the
reliquary of St. Helena in
the church of St.-Leu in
Paris, this compound twill
or samit has two colors
forming the weft face of
the wonderful senmurv, a
mythical creature that is
part bird and part lion.

East were prized as exotic trade items in the West and used in ecclesiastical and royal garments, and in church reliquaries. The technique was subsequently taken up in Europe in the medieval period, after which it was supplanted by the new technique of LAMPAS, another type of COMPOUND WEAVE used to create the especially popular *cloth of gold* of Mongol influence. The great silkweavers of the Byzantine era produced samit fabrics of extraordinary width with large roundels filled with animals and hunting scenes.

Technically, samit is formed as a WEFT-FACED compound twill WEAVE STRUCTURE using two sets of WARPS and multiple, complementary sets of polychrome WEFTS used in a single pass. The two sets of warps each serve a different function in the weave structure—one interlaces with the wefts forming the weave and the other functions to separate the color areas, enabling intricate polychrome design details to be achieved. The fabric created with this structure has a single continuous face formed by the wefts, whose color changes construct designs.

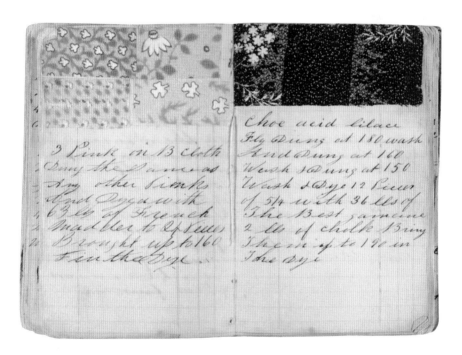

SAMPLE BOOK

Swatch books of the master dyer of the Manchester Print Works (Manchester, N.H.), nineteenth century. 16 × 29 cm (6¼ × 11⅜ in.). MMA American Wing Library, NK8812.M36 1880. Image © The Metropolitan Museum of Art. The recipe indicated below the pink printed fabrics includes 63 pounds of French madder.

SAMPLE BOOK

Used to document working processes for WEAVING, DYEING, and PRINTING, sample books often contain a combination of written descriptions, recipes, and actual samples of materials. Some sample books were compiled by individual weavers or dyers

as personal records; examples of this type have been preserved from as early as the sixteenth century. Others were made by industrial manufacturers as reference guides for design and production.

SAMPLER

Embroidered *samplers* were learning tools used for practice of needlework. Well known are the nineteenth-century American embroidered samplers, produced by young girls as an essential part of their education. These, generally executed in cross-stitch EMBROIDERY on LINEN ground, often included the name and age of the girl who produced it, as well as the school where it was made. Most cultures that produced embroideries seem to have used samplers as a training technique and as a way to produce reference examples of various stitches, patterns, and designs. Woven samplers were also produced, but they have not been preserved to the same extent as the embroidered works, which are often treasured heirlooms.

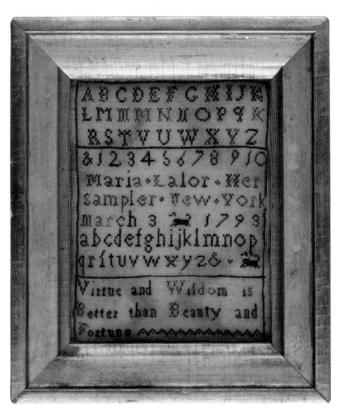

SAMPLER
Embroidered sampler, 1793. Maria Lalor, American (New York City). Silk on linen, 14 × 16.5 cm (5½ × 6½ in.). Gift of Elizabeth M. Riley. MMA 1993.100. Image © The Metropolitan Museum of Art. The motto at the bottom reads: "Virtue and Wisdom is / Better than Beauty and / Fortune."

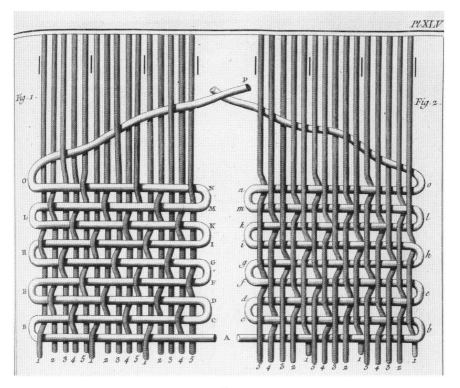

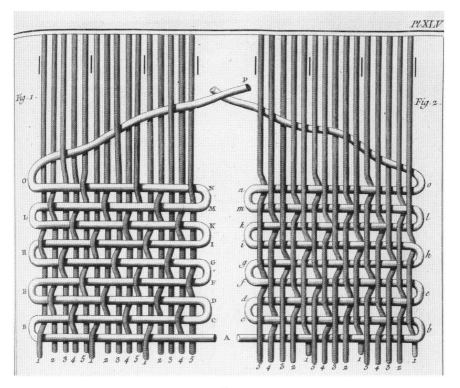

Pl. XLV

SATIN

Encyclopédie, Diderot, Denis, and Alembert, Jean Le Rond d', Paris, [1762–72]. Plate XLV [YY]
GRI 84-B31322. This plate shows the woven structure of five-harness satin. On the left is the back
face, and on the right, the front face.

SATIN

A WEAVE STRUCTURE with a surface of long FLOATS, bound in a systematic way, but
whose binding is not readily visible. *Satin* fabrics, often made of SILK, are particu-
larly lustrous due to the ability of the long float to reflect light. However, if the float
is too long, the woven structure loses its integrity. A number of different systems
were used to bind the structure, using sequences of five, seven, eight, or nine YARNS
(sometimes referred to as "five-harness satin," for example, where the WARP floats
over four and under one, incorporating five yarns altogether). Units of six do not
work mathematically with the structure, which should have *binding points* (the place
where a single WEFT crosses a single warp, or vice versa) that repeat regularly within
the fabric weave. Unlike TWILL, where the bindings occur on adjacent yarns in
diagonal alignment, in *satin,* the points of binding skip one or two yarns, while still
engaging at least once on every yarn, within the five- to nine-thread sequence. This
disperses the binding points, enabling the long floats to appear loose, yet securely
forming the integral woven structure. Diderot's detailed drawing of the binding
structure of a five-harness satin is reproduced here.

Generally, the main or front surface of a satin weave is the face on which the
warps form the floats.

SAVONNERIE

Four-panel screen (paravent), 1719–84. Designed by Alexandre-François Desportes (French, 1661–1743).
France, Savonnerie Manufactory (act. 1627–present). Wool and linen; wood frame (modern corron-twill
gimp; modern silk velvet; modern brass nails), 185.4 × 254 cm (6 ft. 1 in. × 8 ft. 4 in.). JPGM 75.DD.1.
Savonnerie screen formed with Turkish knots (symmetrically knotted pile).

SAVONNERIE

A royal manufacturer of KNOTTED PILE carpets and pictorial upholstery located in
Chaillot (a southern district of Paris), established in the seventeenth century. *Savon-nerie*, literally "soap factory," connotes both the particular manufactory (established
in a former soap factory) and the distinctive knotting technique, the symmetrical
Turkish knot used in Near Eastern carpets, adapted for European production.

SELVAGE

The woven edge of a fabric. A WEFT selvage, created along the sides of the cloth, is
formed as the weft reaches the edge and turns back through the next weaving SHED.
A WARP selvage—made only in certain types of LOOM setups—is created along the
top and bottom of the woven textile, within the first and last few passes of the weft,
at the extreme end of the warp. Andean weavers produce highly distinctive four-
selvaged cloth, in which the warp and weft YARNS remain uncut and finished along
all four edges.

Selvages serve both physical and social functions. Physically, they can help to maintain the lateral edges of the cloth: to this end, they are often woven in heavier or doubled yarns or a sturdier weave than the rest of the textile. They have also served throughout history in part as a place to mark features of a fabric, for example, using specific colors or stripes as indicators of quality or use of a specific dyestuff, or to signal compliance with local guild regulations for taxation or export. According to SILK guild regulations in sixteenth-century Italy, a red VELVET that was dyed with the expensive KERMES dye was to have a green selvage with a silver thread running down the center (Molà, 2000).

SHED

The opening for the passage of the WEFT yarn created by lifting (or lowering) specific sets of WARP yarns across the LOOM. The composition of the *shed*—that is, which yarns are lifted and which remain on the bottom—is dictated by the fabric structure. A simple PLAIN WEAVE, for example, uses two sheds, one composed by lifting even-numbered warps and the other by lifting odd-numbered warps. Other more complex WEAVE STRUCTURES will use multiple sheds for the weaving process.

SHELLFISH PURPLE

In antiquity, *shellfish purple* was a DYE of the highest value, prescribed for use in ritual garments according to the Hebrew Bible and sought after by Roman and Byzantine emperors, Catholic popes, and European kings as the designated color of rank, authority, and privilege (see fig. 2). The dye comes from the secretions of small marine animals of the Muricidae family: *Bolinus* (formerly *Murex*) *brandaris* and *Hexaplex* (or *Murex*) *trunculus*, and a few other related species. Secreted as a white liquid, it turns brilliant purple—with shade tints from bluish to red—in sunlight.

SHELLFISH PURPLE
Murex, engraved plate from *Delle Porpore* (Milan, 1736 [?]).
GRI 93-B4532.

Mediterranean practice was to kill the animal to extract the fluid, resulting, by the fifteenth century, in the exhaustion of supplies and the near-extinction of the species. Tens of thousands of shells—evidence of an active industry—have been excavated in sites in Italy, Greece, and Carthage. Species native to Central and South America, such as *Plicopurpura pansa* and *Concholepas concholepas*, were used by pre-Columbian cultures. These mollusks were "milked" on-site at their rocky seashore habitats and subsequently returned to the sea, a more sustainable practice that is still in use today.

SHIBORI See RESIST DYEING.

SHUTTLE

A device for holding WEFT yarns for insertion into the WARP SHEDS during WEAVING. A shuttle can be a stick or a wooden container with a bobbin, with an opening for the thread to unfurl as it passes across the LOOM width.

SILK

A fiber derived from secretions of the silkworm, which in actuality is the larval form (caterpillar) of a moth. In addition to the cultivated species, *Bombyx mori*, which eats exclusively mulberry leaves, there are a number of wild moth species that make silk. *Bombyx* was originally native to China, where it has been cultivated since early Neolithic times.

Because of its many desirable qualities—the fiber is long, strong, lustrous, and lightweight, and takes dye readily—silk was an early trade item, from at least the second and first centuries B.C. It was the primary impetus for the establishment of long-distance overland trade routes, collectively known as the Silk Road, over which caravans transported the lightweight treasure across the deserts of western China, through Central Asia and the Near East, eventually to Antioch on the Mediterranean and thence to Europe.

Silk is produced as the caterpillar secretes a substance from a pair of glands, creating a continuous filament of pure *fibroin*, an insoluble protein. It continuously wraps this filament around itself to form a protective cocoon, inside which it makes its metamorphosis from larva to chrysalis or pupa, prior to emerging as a moth. To use the silk, traditional practice has been to steam or boil the cocoon, killing the worm before it hatches, and then to unwind the long filament with meticulous care, resulting in a single, continuous fiber. (If the moth emerges, the filaments will be broken. These broken cocoons are harvested as well, but the fiber must be spun, as it is in short pieces rather than one continuous length.) One silk cocoon yields between 350 and 1,200 meters of filament. The proteinous silk fiber is composed of two separate filaments called *brins*, which are covered with a sticky material, *sericin*, which allows the silkworm to cement its cocoon. For WEAVING, the sericin, or *silk gum*, is generally removed in a process called *degumming*. Though very fine, silk fiber is extremely strong, and its long, smooth surface reflects light. Many cultures use silk without SPINNING in order to enhance this light-reflecting quality.

The origins of *sericulture*, like those of the silkworm, have been attributed to China. The earliest silk textile fragments to have survived, dating to ca. 3630 B.C., were found associated with a child's burial at Qingtaicun in Henan Province, central northern China (Vainker, 2004). Recent study of archaeological remains in the Indus Valley demonstrate that silk was present outside of China by 2450 B.C. (Good et al., 2009). It is not yet known whether this silk derived from *Bombyx* or a different variety of silkworm (see WILD SILK).

SILKSCREEN PRINT

A modern technique in which an image is transferred onto a fine mesh screen for printing onto fabric. Some areas of the screen are blocked to prevent transfer of the colorant when it is hand-applied. Separate screens are used for each application of color. *Silkscreens* have been used since the early twentieth century by artists and craftsmen.

SILKSCREEN
Golf Magic, designed by Brian Connelly, produced by Associated American Artists, American, ca. 1953. Cotton, printed on plain weave, 182.9 × 89.5 cm (72 × 35¼ in.). Museum purchase through gift of Mrs. William Goulding. CH 2002-23-1. © Cooper-Hewitt, National Design Museum, Smithsonian Institution / Art Resource, NY. Photo: Matt Flynn.

SLIT See TAPESTRY WEAVE.

Lewis Wickes Hine (American, 1874–1940), *Sadie Pfeiffer, Spinner in Cotton Mill, North Carolina*, 1910. Gelatin silver print, 1920s–1930s, 27.9 × 35.6 cm (11 × 14¹⁄₁₆ in.). JPGM 84.XM.967.15.

SPINDLE

A shaft with a pointed tip used for spinning FIBER into YARN, often with a weight or whorl. Some *spindles* are used resting the lower tip on a stable surface while others are suspended in the air while they twist. Turning of the spindle can be done by hand, with a foot-powered *spinning wheel*, or by mechanically powered industrial equipment. See SPINDLE WHORL, SPINNING.

SPINDLE WHORL

A round weight used on a hand SPINDLE to add momentum for spinning yarn. Depending on the fiber, the size can vary. A small weight suffices for spinning COTTON, while a heavier one with a larger diameter is needed for WOOL. Weights may be made of stone, clay, wood, or vegetable matter. Some cultures decorate *spindle whorls* with designs that may have significance to the spinner. Modern industrial techniques, which employ electric or water-powered spindles, do not require the whorl for momentum during the process of spinning.

Spinning

The twisting of a mass of FIBERS in one direction to create a YARN. *Spinning* can be done by hand with fingers or with the palm or heel of the hand against a knee, with a SPINDLE and SPINDLE WHORL (supported or unsupported), with a hand-wheel, or with a machine-driven wheel.

To prepare fibers for spinning, they are cleaned of extraneous materials such as dirt, plant materials, and oily substances, and then aligned by use of *teasels, carding combs*, or other equipment. The prepared fiber is then gathered into a mass. Sometimes, as with WOOL, it can be organized into a *roving* (a length of ready-to-spin material). The spinner then selects a quantity of fiber to be pulled and twisted into yarn. The art of spinning lies in maintaining a consistent amount of fiber to be pulled and a consistent amount of twist to the yarn, so that the end result is even and uniformly twisted lengths of yarn.

Depending on the position of the spindle, yarns are twisted either in a clockwise or counterclockwise direction. The *direction of spin*, viewed on a yarn in a vertical position, is identified as *S-spun* or *Z-spun*, matching the central diagonal of the respective letters; these are indicated as \ (for S) or / (for Z) in analytical notation. See more at PLY.

Spinning
The yarn is composed of three S-twisted strands, plied Z. Photo: author.

SPRANG

Mantle, Peru (Ocucaje), second–first century B.C. Wool, 137 × 188.9 cm (54¼ × 74⅜ in.). Gift of Rosetta and Luis Slavitz. MMA 1986.488.1. Image © The Metropolitan Museum of Art. The mantle is constructed of multiple panels made in sprang.

SPRANG

A technique of intertwining a single set of YARNS, *sprang* was often used for bags, hammocks, and head coverings as it creates a sturdy yet flexible openwork. In producing sprang, both ends of a set of yarns are anchored onto a frame or type of LOOM. The yarns are then twisted by hand, one over the next across the width. A twist at one end causes a countertwist on the other end. A cord is then inserted through the center to keep the twisted threads in place; its removal will unravel the entire network. Complex sprang was made in Peru, where double and even triple layers of threads were interworked in elaborate designs.

STENCIL

A design tool traditionally made of heavy paper with a pattern cut out of it, used to transfer designs through the application of a DYE, MORDANT, or resist paste onto cloth. With dye and/or mordant application, the result is the positive image of the cut pattern. By using the stencil for applying a resist paste (and subsequent dyeing), a negative image is formed.

STRAIGHT REPEAT See DESIGN REPEAT.

SUPPLEMENTARY

In a woven fabric, *supplementary* elements (either WARPS or WEFTS, or both) are those that may be interwoven with the ground fabric to create patterns or designs, but that do not form the basic GROUND WEAVE of the cloth. The removal of supplementary elements does not interfere with the woven structure. They can be continuous or DISCONTINUOUS along the length and width of the fabric, often as a FLOAT WEAVE used on the surface to form the designs. (See Introduction, fig. 13.)

SYNTHETIC DYE

Dye made through chemical synthesis, as opposed to NATURAL DYE, which occurs in nature. In the mid-nineteenth century, the development of SYNTHETIC DYES—manufactured through a variety of chemical processes to mimic the behavior and structure of natural dyes—revolutionized the textile industry. Instead of relying on harvested plant materials, the quality and quantity of whose colorants could vary from year to year and source to source, the industry could now employ chemists to produce uniform dyestuffs. Scientists had been experimenting with chemical dye compounds for some time; *Prussian blue* was made from ferric acid as early as 1704, and in 1820 *chrome yellow* was derived from lead nitrate and potassium bichromate. The first completely synthetic dye, created from coal tar, was *mauvine*, a brilliant purple, patented by W. H. Perkin in 1856/57. Indigo was synthesized in the late nineteenth century, followed by *alizarin red* from madder, and a wide array of other colors. Many of these early synthetic dyes were quite unstable and faded rapidly when exposed to light. New categories of synthetic dyes are being produced up to the present day for use by the textile industry. See also DYE.

TABBY See PLAIN WEAVE.

TABLET WEAVING

Weaving with a series of perforated tablets that act as a shedding device. The tablets, made of leather, wood, carton, or ceramic, are usually square shaped (though they may also be triangular or octagonal) with at least four holes. The WARP yarns are

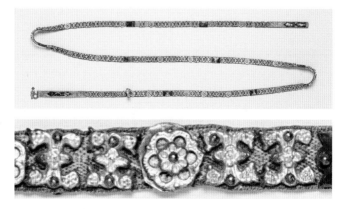

TABLET WEAVING
Girdle with profiles of half-length figures (detail), Italian, ca. 1400. *Basse taille* enamel, silver-gilt, mounted on fabric, 175.3 × 2.5 × 1.7 cm (69 × 1 × 11/16 in.). Gift of J. Pierpont Morgan. MMA 17.190.963. Image © The Metropolitan Museum of Art. The fabric belt is tablet woven.

threaded through the holes, and turning the tablets opens SHEDS for WEFT insertion. *Tablet weaving* was used historically to create narrow patterned bands, belts, and trimming. Some of the earliest finds come from Northern Europe, where tablet weaving was used to create the starting borders of fabrics woven on warp-weighted LOOMS. The distinctive twisting of pairs of warp yarns hallmark the tablet-woven fabric, which can otherwise be difficult to differentiate among other early belt-weaving and braiding techniques.

TAFFETA

A term for a specific type of WARP-FACED PLAIN WEAVE fabric. Often *taffeta* is made using slightly thicker WEFTS, which are hidden by densely spaced WARPS that cover the surface, creating visible ribs across the width of the fabric. SILK taffeta fabrics often have a sheen and were sometimes patterned after weaving by MOIRÉ.

TANNIN

Any of several natural compounds used for dyeing. *Tannins* are found in the barks of various trees, particularly oaks; in oak galls or gallnuts; in sumac leaves; in the heartwood sap of certain trees (for example, *cutch* from the acacia tree); in certain fruits (such as *myrobalans* or *betel*) and their skins (such as pomegranate); and in the seedpods of some trees. Throughout history, tannins have been used to make various shades of beige, brown, and black, and also as MORDANTS for other DYES. Tannins are also used in leather tanning. The combination of tannins with iron creates very dark brown or black colors, which are used extensively in textiles even though this corrosive combination deteriorates the fibers. This mixture also makes *iron gall ink*.

TAPESTRY

As an object, a *tapestry* is usually (but not exclusively) a large, pictorial wall-hanging woven in TAPESTRY WEAVE (see below). In Europe, tapestries were often made in series and are perhaps best known from the medieval period, when elaborate allegorical and religious scenes were rendered as woven narratives, and from the Renaissance, when more elaborate and sumptuous artworks, richly woven in polychrome WOOL, SILK, and gold, were made after CARTOONS designed by great artists of the period. In Asia, the tapestry technique called KESI was used for weaving extremely fine pictorial hangings, as well as special garments and furnishing fabrics. In ancient Peru, tapestry was used for refined and high status garments, notably under the Inca Empire (1438–1532); their double-faced tapestry cloth is referred to as *cumbi*.

All of these pictorial traditions exploited the TAPESTRY WEAVE structure, which enables the weaver to concentrate on one surface (the WEFT face), which is formed by tightly packed interlaced yarns, to create the images. The design is constructed through a number of different methods, using changes in color and in some cases texture to delineate the images. See also LOOM, CARTOON.

TAPESTRY

Don Quixote Cured of His Folly by Wisdom (overall and detail), from the series The Story of Don Quixote, woven at the Gobelins Manufactory (French, act. 1662–present), 1773. Silk and wool, 370.8 × 386.1 cm (12 ft. 2 in. × 12 ft. 8 in.). JPGM 82.DD.66. The detail below shows the artist's signature and date woven in the lower right corner.

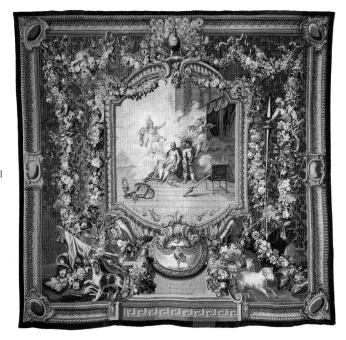

TAPESTRY WEAVE

A WEFT-FACED PLAIN WEAVE with DISCONTINUOUS weft structure, tapestry weave utilizes many different colored weft yarns to create the pictorial designs. These discontinuous yarns change constantly across the width of the tapestry. A number of methods were used to create these color changes or *joins* while maintaining a uniform surface throughout a work of art that was often very large.

Slit joins: Weft yarns interlace in their respective color areas and turn around at adjacent warp yarns, leaving an opening or slit in between. (This is also the method used in *kilims*. See RUG WEAVING.) When the design forms rectangular color blocks, large slits may result that are sometimes sewn up after the weaving is completed.

Dovetail joins: Weft yarns from adjacent color areas alternately turn around along a single warp. Dovetail joins may be formed by single pass or multiple passes of the wefts (two or three of one color, followed by two or three of the adjacent color), which may be visible as slight wedges at the point of juncture.

Interlocking joins: Weft yarns from adjacent color areas interconnect as they return into their respective color areas, interlocking the yarns in a single or double pass around or between a single warp. *Single interlock joins* are almost invisible, whereas *double interlock joins* form a noticeable ridge at the back.

Weavers have used diverse tricks and techniques to translate a design into a woven tapestry. They use *hatching*, a series of lines of contrasting colors in the weft, to modify color and create shading, giving three-dimensionality to forms. *Eccentric*, or non-horizontal wefts, are used to form curved design features, rather than adhering to the rigid grid format of weaving. Yarns may be added that combine colors or textures, changing from WOOL to SILK to highlight special areas and create finer textures. For bright contrasts, white LINEN or COTTON yarns may also be used. METALLIC YARNS add depth and brilliance. SUPPLEMENTARY weave structures can create a raised, patterned surface in select design areas.

Another feature of tapestry weave is referred to as "*lazy lines*," in which adjacent diagonal wedges of yarns of the same color are built up during weaving. Used by weavers worldwide, these lines may simply demarcate work sections produced by one or more weavers, or they may be seen as breaking the monotony of expanses of single color areas, adding texture to the surface while maintaining proper tension. Some cultures, such as the Navajo, imbue these with spiritual meaning, and their tapestry-woven blankets often have lazy lines.

The quality of tapestries depends on, among other criteria, the original design conception; the skill of the weavers in translating that design into the tapestry using the techniques enumerated above; the quality of the yarns and materials; the density of the warps and wefts (the warp and weft COUNTS); and the surface features constructed during the weaving process.

TOILE DE JOUY See COPPERPLATE PRINT.

TRADE CLOTH

A general term for cloth produced in one country and traded to another, but specifically it refers to the red, blue, and green woolen cloth known as *baize* in England, where it was woven with WORSTED WOOL, then boiled and felted. This cloth was known as *bayeta* in Spain and Spanish America and as *baai* in Flanders and the Netherlands, beginning in the sixteenth century (Wheat, 2003). Trade cloth was generally a PLAIN WEAVE yardage cloth, sometimes woven in TWILL. With its brightly dyed colors and sturdy woolen FELTED surface, it was highly sought after by many cultures and used by European trading companies into the nineteenth century as currency and for barter and trade throughout South and Southeast Asia, Africa, and the Western United States. Red woolen *trade cloth*, either as raveled yarns or whole cloth scraps, was used around the world for the embellishment of garments and sacred objects; it turns up, for example, in seventeenth-century Taiwanese ethnic jackets, in seventeenth-century Japanese Samurai surcoats (*jimbaori*), in nineteenth-century African spirit sculptures, and in Native American clothing and ritual bundles. See FELTING.

TURKEY RED

A process for dyeing COTTON red with MADDER, it is associated with Ottoman Turks, hence the appellation. It is, however, thought to have originated in India, to which both cotton and madder are native. The *Turkey red* process circumvents the natural lack of chemical affinity between these two materials.

A complex sequence of steps is involved, each of which produces changes in the chemical state of the fabric and prepares it for the next step. The scoured fabric must first be soaked in milkfat, lard, or vegetal oil and soda ash (sodium carbonate), followed by a dung bath. These steps are referred to as *oiling* and *dunging* in early seventeenth-century descriptions. The fabric is then rinsed and hung out in the sun for several days. The cycle of oiling, dunging, rinsing, and sun exposure is repeated six or seven times. Then the cloth is soaked in a solution of TANNIN, followed by MORDANTING with alum and drying. Then follows a final dunging, after which the cloth is immersed in a madder dyebath, along with other components, often repeatedly. It was finally boiled in lye soap and soda ash for cleaning and brightening, sometimes with added tin salts (Liles, 1990). This process, or some variation thereof, was used to dye cotton and linen a bright red color until the advent of synthetic red dyes in the last quarter of the nineteenth century. The illustration accompanying APPLIQUÉ is an example of Turkey red. See also CHINTZ.

TWILL

A basic WEAVE STRUCTURE in which sequential threads skip or float over one or more INTERLACEMENTS in a diagonal alignment, with a minimum of three WARPS and three WEFTS forming a unit. *Twills* are described according to the number of warps and wefts that float in sequence. For example, a one-two (1/2) twill (which creates a WEFT-FACED fabric) has one binding point where the weft goes under one warp and

over two. A 2/1 twill is the opposite—that is, it creates a WARP-FACE to the fabric, where the warp floats over two wefts, then under one. Twills can be composed also as 1/3 or 2/2 in a regular sequence. *Herringbone* or *diamond* twills can be made using the basic structure of the twill but altering the way it is threaded on the LOOM and the sequence of treadling for weft insertion (1-2-3, 1-2-3 vs. 1-2-3—3-2-1 or 1-2-3-2-1). Twill weaves, made on warp-weighted looms, are among the earliest types of woven cloth preserved; examples have been unearthed at the Northern European Iron Age sites of Hallstatt, Austria (ca. 1200–400 B.C.). They have also been found on wool cloth from Western China, from around the same period.

VELVET

A fabric appreciated for its lush, dense PILE surface, which contributes to its depth of color. *Velvet* is woven as SUPPLEMENTARY warp loops on a foundation; the loops are usually later cut, resulting in the raised surface pile, but may also remain uncut. The loops are formed during weaving, between two passes of the weft: the supplementary pile warps are lifted, a rod (sometimes called a wire) is inserted to maintain them at a uniform height, then the warps are lowered with the rod in place. The weaver later manually cuts the loops across the width of the fabric with a sharp blade, using the rod as a cutting surface.

VELVET
Velvet fragment, Italian, sixteenth century. Silk, 35.6 × 26.7 cm (14 × 10½ in.). Gift of Nanette B. Kelekian, in honor of Olga Raggio, 2002. MMA 2002.484.469. Image © The Metropolitan Museum of Art. The velvet is made with two heights of pile (pile on pile) enriching the pattern.

VELVET

Portrait of an unknown daguerreotypist in a velvet-lined case, American, 1845. Hand-colored daguerreotype,
6.67 × 5.24 cm (2⅝ × 2¹⁄₁₆ in.). JPGM 84.XT.1576.1. The velvet used in the case has a stamped or embossed design.

The foundation weave of velvets can be a PLAIN WEAVE, TWILL, or SATIN struc-
ture. The cut loops may cover the entire surface, resulting in a plain velvet fabric,
or designs can be woven with alternating areas of pile and non-pile (*voided velvet*);
by alternating areas of cut and uncut pile (*ciselé*); by constructing pile in two levels
(*pile-on-pile velvet*); or by introducing supplementary wefts for added features, such
as METALLIC YARNS covering the background or forming weft loops (*bouclé*). After
the velvet is woven, designs can also be added by stamping with pressure into the
surface (*embossed* or *stamped velvet*). Velvet is generally made of SILK, but the WEAVE
STRUCTURE can be made of other materials. Some of the earliest precursors to velvet
weave—that is, warp loops formed on a foundation—come from Egypt from the
Late Antique period, using uncut loops of LINEN.

Many cultures have produced velvet, and its development is associated with
technical developments of the LOOM. Velvets were always luxury items, requiring
substantial amounts of silk and, often, gold and silver as well. Italian velvets, pro-
duced from the fourteenth century, held pride of place in the vital textile industry
of the region. Venice was renowned for its luxurious velvet weaves, and knowledge
of the production methods was jealously guarded by artisan guilds and town mag-
istrates, who enacted laws to protect them. Safavid Persian weavers produced lush
figurative velvets, combining metal ground surfaces with silk pile in multiple colors
(see Introduction, fig. 1). Turkish weavers, notably those of Bursa and other Ana-
tolian regions, produced complex velvets with large-scale designs for the court of
Süleyman and subsequent Ottoman dynasties between the fifteenth and seventeenth
centuries. The Chinese, who also wove velvets, used cut and uncut design areas for
Buddhist ritual hangings in the fifteenth–sixteenth centuries.

Velveteen

A plush PILE fabric made of weft-pile (as opposed to the warp-pile of true velvet) and often made of COTTON rather than SILK, *velveteen* was popular particularly in the nineteenth century. William Morris, Candace Wheeler, and other European and American textile producers designed and manufactured furnishing fabrics of cotton velveteen aimed at the middle-class consumer. The use of cotton and industrial production methods made velveteen far less costly than velvet.

Warp

The first set of elements used in WEAVING. The term applies to both the individual YARNS and to the entire group of yarns (or set) that functions in the structure of a fabric. Placed on the LOOM first, the *warp* position is perpendicular to the WEFT. While often the warp forms the longer dimension of a fabric, in some cultures, depending on the loom, it can be the shorter dimension.

Warp direction

When examining a textile, one of the first tasks is to determine its *warp direction*. Identifying the warp direction can lead to revelations about the WEAVE STRUCTURE, the LOOM, and the patterning mechanism, which will aid subsequent technical analysis. In archaeological or fragmentary textiles, however, this is often a challenge. Knowing the provenance, culture, date, or ethnicity of the textile is very helpful. Finding the WEFT SELVAGE can be a first clue.

The warp is often, but not always, the longest direction in a complete textile. Sometimes the design or pattern is woven along the warp direction but it may also be woven perpendicular to it. By convention, scholars use an arrow to indicate the warp direction in photographs or diagrams.

Warping

The process of measuring out the WARP yarns and placing them on the LOOM. To prepare the warp for weaving, the yarn needs to be measured and ordered. Some cultures use a single, continuous yarn for the warp, passing it around two (or more) sticks held in position to form the desired length. The measuring out of the yarn also sets the order of the yarn for placement on the loom. Many cultures lay out the warp in a figure-eight so that every other yarn crosses the alternate yarn. This crossing point forms the two SHEDS for a PLAIN WEAVE interlacement and is preserved when the yarn is placed on the loom. The point where the yarn turns around the stick becomes the warp end. This is either cut or remains as a loop, depending on the loom used.

Warp-faced

A woven fabric that shows a predominance of the WARP yarns (covering the wefts) on its surface. The opposite is WEFT-FACED. The illustration at WARP-PATTERNED is *warp-faced*.

VELVETEEN
Printed and woven cotton velveteen (detail), designed by Candace Wheeler (American, 1827–1923) for
Associated Artists (New York, 1883–1907), 1883–1900. Cotton, 82.6 × 94 cm (32½ × 37 in.). Gift of Mrs.
Boudinot Keith, 1928. MMA 28.70.25. Image © The Metropolitan Museum of Art.

WARP-PATTERNED

Patterning of a fabric achieved by the WARP yarns, which either float or are bound
in sequence to make designs. *Warp-patterned* fabrics are also generally WARP-FACED.
Chinese weavers during the period of the Han dynasty (Western Han 206 B.C.–A.D.
9, Eastern Han A.D. 25–220) created warp-patterned designs in silk. Warp-pattern-
ing is often found in narrow bands, as in the *pallai* of the Andean weavers of high-
land Peru and Bolivia.

WEAVE STRUCTURE

Weave structures form the foundation of woven textiles. They are regular, repeated sequences of interlacements between WARP and WEFT. While there are many types of structures, they can be categorized by basic components, including the repeat sequence of how the warp and weft float over and under each other, and how many different groups of warps or wefts with different functions are involved in making the structure. Overall, we can sort them into two categories—simple weaves and compound weaves.

Simple weave structures: PLAIN WEAVE, TWILL, SATIN, and GAUZE constitute the four basic weave structures, each of which has its particular sequence of interlacement, with a number of possible variations. These simple weaves—composed of one set of warps and one set of wefts—form the basis for interlacement of most of the more complex compound weaves. Simple weaves can be embellished with SUPPLEMENTARY warps and/or wefts, which can float on the surface, unbound or bound in a structure. See FLOAT WEAVE, SUPPLEMENTARY.

Compound weave structures can generally be recognized by how the pattern or design is formed—whether the textile has a uniform surface with the design composed with a singular construction but with multiple colors, or has a number of surfaces created by the weave (through the juxtaposition of warp or weft FACES of different weaves, for example). To create the designs, compound weaves are formed in several fundamental ways. One way is to use a single complementary set in one direction (either warp or weft) that has a single function, but with multiple colors of yarns, and two sets of the opposite (warp or weft) direction that function differently from one another. Of these, one set performs a structural function by binding the weave structure (for example, in a twill weave) while the other acts as a separator for the multiple-colored yarns, allowing colors to be selected for the pattern, maintaining them on the front surface of the textile, while keeping the others to the back, all the while being bound by the first set (see, for example, SAMIT). The second fundamental type of compound weave uses two or more completely different sets of warps and wefts to create separate but interconnected textile structures. These can result in a textile with multiple layers that intersect according to the pattern to form a unified textile, as in DOUBLECLOTH. Alternatively, the two parts can be integrated into a single layer that features two or more types of interlacing weave structures; a LAMPAS, for example, is composed of a combination of plain weave and twill.

Like the simple weaves, compound weaves can be embellished with supplementary warps and/or wefts.

WEAVING

At its most basic form, weaving is the process of perpendicularly interlacing two groups of yarns: WARPS and WEFTS. *Weaving* takes place on a LOOM, from the most simple, composed of two sticks, to the more complex, such as the DRAWLOOM or JACQUARD LOOM.

Weft

The second set of elements or yarns on the loom that interlace with the WARP. Woven perpendicularly to the warp, the *wefts* pass across the width of a fabric. A continuous weft interlaces across the entire width and turns around at the SELVAGE edge to return across to the other side. A DISCONTINUOUS weft (as in TAPESTRY WEAVING) is used only in specific areas, to execute a design. See TAPESTRY.

Weft-faced

A woven fabric in which the WEFT yarns form the primary surface of the textile and cover the WARP. TAPESTRY WEAVE, for example, is *weft-faced*, as is the fabric woven in compound TWILL known as SAMIT. See SAMIT, TAPESTRY WEAVE.

Weft-patterned

A fabric in which the design is composed by the weft yarns, often as SUPPLEMENTARY floats, or as COMPLEMENTARY structures. See FLOAT WEAVE.

Wild silk

Wild silk, sometimes called *tussah silk*, comes from wild species of silkworms. In addition to the cultivated mulberry silkworm (*Bombyx mori*), a number of related caterpillars, of the genera *Antheraea* and *Attacus*, among others, also produce SILK cocoons. Species native to Japan, China, India, Africa, and the Americas have been used for textile fibers. Tussah silk from *Antheraea mylitta* in India lives on the leaves of the castor-bean plant, produces very large cocoons, and has a brownish or yellowish natural color. Others eat oak leaves.

Noncultivated silkworms, like their cultivated counterparts, produce cocoons enclosing their larval stage, but they generally complete the life cycle and eat their way through the layers of filament, emerging as adult moths. The broken cocoons are then gathered and processed for making silk yarns. Because the long filament has been broken into pieces, the fiber needs to be spun into yarns. Such broken silk filaments are not as lustrous as those of cultivated, reeled silk, and the resulting textiles have a rougher surface quality and lack the luster associated with the cultivated variety. Nevertheless, wild silk is highly prized for its own intrinsic qualities, including the fact that the insect is not killed in order to use its silk. This practice comports with the religious precepts of Buddhists and other groups, which prescribe respect for nature. This is why wild silk is sometimes referred to as "Buddhist silk." See also SILK.

Woad See INDIGO.

Wool

Animal hair, particularly from sheep. Animals have various types of hairs, including *guard hair*, which is coarse and thick, and *undercoat hair*, which is softer and finer with some crimp. It is the undercoat hair that is used for SPINNING. *Wool* is

composed primarily of the protein *keratin*. The surface of each individual hair is covered with microscopic scales, which facilitates its ability to be spun into yarn: the fibers stick or catch on each other by the scales. (See Introduction, fig. 15.) Sheep's wool fibers can range from 1 to 8 inches in length and from 0.0018 to 0.004 inches (10–100 microns) in diameter. Wool is generally curly, though some sheep breeds, such as the English Lincoln and Leicester and the Australian merino, have been cultivated for their long, silky coats. The fiber is naturally coated with oil, *lanolin*, which is generally washed away prior to use. Preparation of wool requires shearing the hair from the animal, cleaning, orienting the fibers into a single direction or even mass (*combing* or *carding*), and rolling the masses of fibers into ready lengths (*roving*) to facilitate the spinning process. Wool can be dyed before or after spinning or weaving.

Sheep were not always the wooly fleeced animals that we know today. When they were domesticated from wild breeds in Neolithic times, their primary use was for meat. In early prehistory, sheep's wool was not sheared, but rather was pulled or plucked from the animal, or gathered from fleece shed during seasonal molts. During the Iron Age, new technologies, including metal shears that could be used for fleecing the sheep, greatly increased production of wool. Some of the earliest evidence of wool comes from the archaeological sites located in Anatolia, Mesopotamia, and Eastern Iran, the native territory of the aboriginal sheep (Forbes, 1964). The earliest preserved textile remains made of spun and woven sheep's wool are from Shahr-i Sokhta in Eastern Iran, with samples ranging in date from 3100 to 1800 B.C. (Good, 1999). Wool became one of the primary fibers of Mesopotamia and the Mediterranean world, and throughout Europe it formed the basis for the early textile industry.

Worsted

Long-stapled WOOL fibers (staple being the measure of the individual fiber length), which have been combed to align the fibers so that they are more or less parallel, prior to spinning. *Worsted* wool has a smooth, lustrous appearance, as opposed to *carded* woolen yarns, which have short-stapled fibers that give the yarn a matted, fuzzy appearance.

Yarn

A length of FIBER, twisted or spun, that is used for making a textile. Yarns may be thin or thick, composed of single or plied elements, of varying lengths. See SPINNING, PLY.

Selected Bibliography

Balfour-Paul, Jenny. *Indigo.* London, 2006.

Barber, Elizabeth W. *The Mummies of Ürümchi.* New York, 1999.

Bier, Carol, ed. *Woven from the Soul, Spun from the Heart: Textile Arts of Safavid and Qajar Iran (16th–19th Centuries).* Exh. cat. Washington, D.C., Textile Museum, 1987.

Bremer-David, Charissa. *French Tapestries and Textiles in the J. Paul Getty Museum.* Los Angeles, 1997.

Broudy, Eric. *The Book of Looms.* New York, 1979.

Brunello, Franco. *The Art of Dyeing in the History of Mankind.* Vicenza, 1973.

Burnham, Dorothy K. *Warp and Weft: A Dictionary of Textile Terms.* Toronto, 1980.

Campbell, Thomas P. *Tapestries in the Renaissance: Art and Magnificence.* Exh. cat. New York, Metropolitan Museum of Art, 2002.

Cardon, Dominique. *Natural Dyes: Sources, Tradition, Technology, and Science.* London, 2007.

Cavallo, Adoph. *Medieval Tapestries in the Metropolitan Museum of Art.* New York, 1993.

Chenciner, Robert. *Madder Red: A History of Luxury and Trade: Dye Plants and Pigments in World Commerce and Art.* Richmond (U.K.), 2000.

CIETA (Centre international d'étude des textiles anciens). *Vocabulary of Technical Terms.* Lyon, 2006.

Collingwood, Peter. *The Techniques of Rug Weaving,* New York, 1950.

————. *The Techniques of Tablet Weaving.* New York, 1982.

Desrosiers, Sophie. *Soieries et autre textiles de l'antiquité au XVIe siècle.* Paris, 2004.

D'Harcourt, Raoul. *Textiles of Ancient Peru and Their Techniques.* Seattle, 1962; rev. ed. 1974.

Emery, Irene. *The Primary Structure of Fabrics: An Illustrated Classification.* Washington, D.C., 1966.

Forbes, R. J. *Studies in Ancient Technology,* vol. 4. Leiden, 1964.

Gillow, John, and Bryan Sentance. *World Textiles: A Visual Guide to Traditional Techniques.* New York, 2005.

Gittinger, Mattiebelle. *Splendid Symbols: Textiles and Tradition in Indonesia.* Washington, D.C., 1979.

————. *Master Dyers to the World: Techniques and Trade in Early Indian Dyed Cotton Textiles.* Exh. cat. Washington, D.C., Textile Museum, 1982.

Good, Irene. "The Ecology of Exchange: Textiles from the Third Millenium B.C." Ph.D. diss., University of Pennsylvania, 1999.

————, J. M. Kenoyer, and R. H. Meadow. "New Evidence for Silk in the Indus Valley," *Archaeometry* 51, no. 3 (2009), 457–66.

Irwin, John, and Katherine B. Brett. *Origins of Chintz.* Exh. cat. London, Victoria and Albert Museum, 1970.

Jenkins, David, ed. *The Cambridge History of Western Textiles,* 2 vols. Cambridge, 2003.

LaGamma, Alisa, and Christine Giuntini. *The Essential Art of African Textiles: Design without End.* New York, 2008.

Leona, Marco. *Scientific Research in the Metropolitan Museum of Art.* New York, 2009.

Levy, Santina. "Lace in the Early Modern Period, c. 1500–1780." In Jenkins (2003), 585–96.

Liles, J. N. *The Art and Craft of Natural Dyeing: Traditional Recipes for Modern Use.* Knoxville, Tenn., 1990.

Mair, Victor H., ed. *Secrets of the Silk Road: An Exhibition of Discoveries from the Xinjiang Uyghur Autonomous Region, China.* Santa Ana, Calif., Bowers Museum, 2010.

Mallett, Marla. *Woven Structures: A Guide to Oriental Rugs and Textile Analysis.* Atlanta, 2000.

Matsumoto, Kaneo. *Jodai-gire: 7th and 8th Century Textiles in Japan from the Shoso-in and Horyu-ji.* Kyoto, 1984.

Matthews, J. Merritt. *The Textile Fibres: Their Physical, Microscopical and Chemical Properties.* New York, 1913.

Molà, Luca. *The Silk Industry of Renaissance Venice.* Baltimore, 2000.

Monnas, Lisa. *Merchants, Princes, and Painters: Silk Fabrics in Italian and Northern Paintings, 1300–1550.* New Haven and London, 2008.

Morrall, Andrew, and Melinda Watt. *English Embroidery in the Metropolitan Museum, 1580–1700: 'Twixt Art and Nature.* Exh. cat. New York, Metropolitan Museum of Art, 2008.

Peck, Amelia. *Candace Wheeler: The Art and Enterprise of American Design, 1875–1900.* New York, 2001.

————. *American Quilts and Coverlets.* New York, 2009.

Pfister, R., and Louisa Bellinger. *The Excavations at Dura-Europos: The Textiles.* New Haven, 1943.

Phipps, Elena. *Cochineal Red: The Art History of a Color.* New Haven, 2010.

Picton, John, and John Mack. *African Textiles.* London, 1989.

Rowe, Ann P. *Warp-patterned Weaves of the Andes.* Washington, D.C., 1977.

Saltzman, Max. "Analysis of Dyes in Museum Textiles, or, 'You Can't Tell a Dye by Its Color.'" In *Textile Conservation Symposium in Honor of Pat Reeves,* 1 February 1986, ed. Catherine C. McLean and Patricia Connell, 27–39. Los Angeles, 1986.

Seiler-Baldinger, Annemarie. *Textiles: A Classification of Techniques.* Washington, D.C., 1994.

Sonday, Milton. "Pattern and Weaves: Safavid Lampas and Velvet." In Bier (1987), 57–83.

Song, Yingxing. *Tian gong kai wu: Chinese Technology in the Seventeenth Century,* trans. E-tu Zen Sun and Shiou-chuan Sun. University Park, Pa., 1966.

Standen, Edith Appleton. *European Post-medieval Tapestries and Related Hangings in the Metropolitan Museum.* New York, 1985.

Vainker, Shelagh. *Chinese Silk: A Cultural History.* New Brunswick, N.J., 2004.

Watt, James C. Y., and Anne E. Wardwell. *When Silk Was Gold: Central Asian and Chinese Textiles.* Exh. cat. New York, Metropolitan Museum of Art, 1997.

Weibel, Adèle. *Two Thousand Years of Textiles: The Figured Textiles of Europe and the Near East.* New York, 1952.

Wheat, Joe Ben. *Blanket Weaving in the Southwest.* Tucson, 2003.

Wild, J. P. *Textile Manufacture in the Northern Roman Provinces.* Cambridge (U.K.), 1970.

Wilson, Kax. *A History of Textiles.* Boulder, Colo., 1979.

Zhao, Feng. *Treasures in Silk: An Illustrated History of Chinese Textiles.* Hangzhou Shi, 1999.

Index

Note: Page numbers in **boldface** indicate main topics. Page numbers in *italics* refer to illustrations.

Simon, Mary Hergenroder, *14*

simple weaves, 85. *See also specific types*

sisal, 33

slit joins, 42, 78

Song Yingxing, 7

soumack rugs, 64

South America: camelids of, 18; cochineal in, 20; gauze in, 36; looms in, 48–49; shellfish purple in, 70. *See also* Andes

Spain: cochineal in, 20; embroidery in, 6; figured fabrics of, *34*; kermes in, 42, *42*; lace in, 46; lampas in, 47; metallic yarns in, 53; trade cloth in, 79

Spanish knots, 45

spindle(s), **72,** *72,* 73

spindle whorls, **72,** 73

spinning, **73,** *73*

sprang, **74,** *74*

S-spun yarns, 59, 73, *73*

stamped velvet, 81

Stein, Aurel, *61*

stencils, **74**

stinging nettles, 16

straight repeats, 26, *26*

straight running stitches, 31

supplementary elements, 35, **75,** 78

synthetic dyes, 30, **75**

synthetic fibers, 33

Syria, 30, 47

T

tabby weave. *See* plain weave

tablet weaving, *75,* **75–76**

taffeta, **76**

Taiwan, 79

tannins, **76,** 79

tapestry(ies), **76,** *77*; cartoons for, 18; discontinuous elements in, 28, 86; looms for, 50

tapestry weave, 59, 64, 76, **78,** 86

taqueté, 22, 26, 59

teasels, 73

textiles: approaches to studying, 6–12; history of, 1–6

tie-dyeing, *62, 63*

tin, 54

toiles de jouy, 23

tools. *See specific types*

trade, 5, 19, 20, 65, 70

trade cloth, 33, **79**

treadle looms, 50

tree of life design, 19, *19*

Turkey, 81. *See also* Ottoman Empire

Turkey red, **79**

Turkish knots, *44,* 45, 68

tussah silk, 86

Tutankhamun, 2, 12(n1)

twills, 21–22, **79–80**

U

undercoat hair, 86

United States: doublecloth in, 28, *29*; hooked rugs in, 37, *37*; looms in, 49–50; metallic yarns in, 53; quilts in, *14, 15, 57*; roller printing in, *60*; samplers in, 66, *66*; trade cloth in, 79; velvet in, *81*; velveteen in, 82, *83*

urine, 40

V

vat dyes, 30, 39

velvet(s), *1,* 69, *80,* **80–81,** *81*

velveteen, **82,** *83*

vicuñas, 18

vizcacha, *12, 13*

W

warp(s), **82;** count of, 24; discontinuous, *24,* 28; header on, 37

warp direction, **82**

warp-faced fabrics, **82,** 84, *84*

warping, **82**

warp-patterned fabrics, **84,** *84*

warp-patterned woven rugs, 64

warp-weighted looms, *49,* 49–50

water pattern, 54

watered silks, 54

weave structures, **85;** compound, **21–22,** *22,* 85; counts in, 24; sheds in, 69. *See also specific types*

weaving, **85;** design repeats in, 27; discontinuous elements in, 28; historical resources on, 6–8

weft(s), **86;** count of, 24; discontinuous, *24,* 28, 78, 86; eccentric, 78

weft-faced fabrics, **86**

weft-patterned fabrics, **86**

Wheeler, Candace, 32, 82, *83*

wild silk, **86**

woad, 26, 39

woodblock printing, 59–60

wool, **86–87;** calendared, 54; distribution of, 3–4; dyeing of, 51; in felt, 33; fibers of, 11, *11,* 33, 87; spinning of, 73, 87; as trade cloth, 79

worsted wool, 79, **87**

Y

yarn(s), **87;** count of, 24; plied, 59

Z

Z-spun yarns, 59, 73

Acknowledgments

For those of us who are drawn to them, looking at textiles is an instinctual process. Sometimes we are lucky to hone our abilities with the help of others in the field who share this love and fascination. My earliest memories of textiles are linked to my mother's beautiful silk gowns, whose color and sheen, and even the sound they made as she walked, first sensitized me to the broad range of intellectual, sensory, and indeed emotional meanings that textiles can embody. Later, I was fortunate to work with a number of people who opened new directions for me in textiles, including Mary Jane Leland, who taught the history of textiles at UCLA; Nobuko Kajitani, my teacher and colleague for over twenty-five years at the Metropolitan Museum; Elinor Merrell, a fellow textile devotee whom I met late in her long life; and my distinguished friend and colleague Sophie Desrosiers. To my colleagues at the Metropolitan Museum, especially Christine Giuntini, Tina Kane, Amelia Peck, and others in the conservation and curatorial fields, notably the keepers of textile collections, such as the staff of the Antonio Ratti Textile Center, who help preserve and protect them for the future and have also generously provided access to them—I am extremely grateful. I am also indebted to the scholars of the past, among them Louisa Bellinger, Lila O'Neale, Adèle Weibel, Wolfgang Volbach, Irene Emery, and Gabriel Vial, who have left the legacy of technical scholarship on which today's scholars build. For the present publication, I especially would like to thank staff at the Getty, including the Getty Research Institute Special Collections; Charissa Bremer-David; and the Publications Department book team: Ann Lucke, Kurt Hauser, and Amita Molloy, who helped realize this project.